校園武術規定教材
太極拳

優酷學習太極

The school wushu
Stipulate textbook

《校园武术规定教材—太极拳》
編委會名單

主　編：冷飛鴻

副主編：王小瓊（德國）　　冷飛彤

編　委：黃　嫣　陳曉澄　林敬朗　陳樂鈞　陳樂泓

　　　　黃　莞　黃　淦　陳　冰　汪美汐　冷熙然

　　　　陳堅良　方大东

翻　譯：Philip Reeves（英國）　Alex Nasr(加拿大)

　　　　XiaoQiong Wang(德國)　梁鴻儒（香港）

序言一

　　飛鴻是全國武術太極拳冠軍冷先鋒師傅的兒子，他亦是本校其中一位能夠著重學業之同時，也能發展自己的興趣及所長的好學生。飛鴻自小跟隨父親習武，於2014年參加河南省陳家溝世通太極研究院陳式太極拳培訓班，至今已屢獲國內、香港，以及國際多項太極拳比賽之冠軍及金牌，可見飛鴻在學習及訓練過程中付出了很大的努力，以及經歷了不少艱辛。

　　本人雖不懂武術，亦未曾練武，但以我所認識太極拳是中國傳統武術之一，是以自衛為主，後發制人，借力打力，外觀看非常柔弱。因此，很多人都會認為太極拳是年長的人才去學習。太極拳實則亦是柔中帶剛，可謂剛柔並重，可強身健體及修心養性。本人認為讓孩童自少習武，對他們的身心健康也能有積極正面的影響。現今資訊科技發展迅速，孩子自少便接觸電子科技產品，經常沉浸於視覺及觀感刺激的氛圍當中，而急速的生活節奏亦隨之而生，導致心靈上有很大的壓迫感。正好太極拳也能鍛練人的感知能力，從而提高他們的專注力及自控能力，並能放鬆肌肉及鬆弛神經，可緩解壓力。此外，由於太極拳講求靜心，練習過程中可改善孩子的焦躁和任性，加強他們的耐力和持久力，具陶冶性情之作用。

　　飛鴻性格正面樂觀及處事積極，能尊師重道，待人有禮。特別欣賞他有刻苦和堅毅的精神，並能夠透過自身的努力，將所學編撰成書，推己及人，為發揚中國武術和中華文化出一分力，實踐了本校校訓「力學明德 仁愛樂群」。

<div style="text-align:right">

陳淑儀校長

2020 年 7 月

</div>

Preface1

Feihong is the son of Master Leng Xianfeng, National Wushu Taijiquan Champion. He is also a well thought of student in our school who is able to focus on his studies whilst developing his own interests and strengths. Feihong followed his father from an early age in practising Wushu, and in 2014, he participated in a Chen-style Taijiquan training class at the Shitong Taiji Institute in Chenjiagou, Henan Province. To date, he has won several championships and gold medals in Taijiquan competitions in China, Hong Kong and internationally. In the process of learning and training, Feihong has made a great effort and has experienced many hardships.

Although I cannot claim a deep understanding of martial arts, as I have never practised them, I am well aware that Taijiquan is a traditional Chinese martial arts. Many people believe that Taijiquan is only for older people, but actually Taijiquan represents rigidity in softness, some would say it pays equal attention to rigidity and softness and so can both strengthen the body and cultivate the mind. In my opinion, allowing children to learn martial arts for themselves can also have a positive impact on their physical and mental health.

Nowadays, with the rapid development of technology, children are exposed to electronic devices from an early age and are often immersed in an atmosphere of visual and sensory stimulation whilst our rapid pace of life results in a great sense of oppression for our souls. Taijiquan can exercise our perceptive abilities thereby improving our concentration and self-control while relaxing our muscles and nerves to relieve stress. In addition, because Taijiquan emphasizes meditation, it can improve children's patience and concentration whilst strengthening their endurance and persistence and cultivating a good temperament.

Feihong has a positive and optimistic personality, is proactive, respects his teachers and treats others politely. I especially appreciate his hardworking and persevering spirit. Through his own efforts, he has compiled what he has learned into a book and pushed himself and others to promote Chinese martial arts and Chinese culture. In so doing he has practised the school motto to "study diligently with illustrious virtue, be sociable, kind,and love the community".

Principal Chan Shuk Yee Polly
July 2020

序言二

祝賀《國際武術大講堂系列教學》之一《校園武術規定教材太極拳》新書出版。

太極拳是我國國粹，是一種講求中定、放鬆、心靜、慢練、平衡及自然呼吸的精神修煉。太極拳同時著重身心和肌肉的柔軟伸展，不論男女老少，都可以在任何地方、任何時間練習。有不少科學證據已經證明，太極拳可以鬆弛緊張和焦慮的心理，長期練習太極拳，對人們的身體控制、頭腦思考、心肺功能以及動作靈活性皆有相當幫助。

太極拳結合了中國傳統文化，代表了中華民族的傳統美德，反映了中國人民的和平中庸世界觀。太極拳既適合在校園向學生推廣，亦適合作為與世界各國、各民族間的溝通橋樑；透過體育增進彼此友誼，透過交流增加相互認識；我期望冷飛鴻同學能夠繼續努力、不斷進步、時刻成長，傳承好中華文化，講好中國故事，為社會作出應有的貢獻。

全國人民代表大會常委

前香港民建聯主席

香港立法會議員

譚耀宗

2020 年 7 月

Preface 2

Congratulations on the publication of the book of Taijiquan, one of the teaching materials for campus Wushu in the "International Wushu Series of Lecture ".

Taijiquan is the essence of our country. It is the cultivation of spirit that emphasizes centering, relaxation, calmness, slow practice, balance, and natural breathing.At the same time,Taijiquan focuses on the regulation of the human body, cultivation of mind, and flexibility of muscles by stretching. It can be practiced anywhere and at any time, regardless of men or women and children or the elderly. It has been proved by many scientific studies that Taijiquan can help to relieve tension and anxieties. The long-term practice of Taijiquan is helpful to people in terms of body control, mental thinking, cardiopulmonary function, and flexibility of movement.

Taijiquan combines traditional Chinese culture, represents the traditional virtues of the Chinese nation, and reflects the Chinese people's world view of peace golden mean. Taijiquan is not only suitable for promotion to students on campus, but also suitable as a bridge of communication with other nations and peoples around the world to enhance mutual friendship through sports and to increase mutual understanding through exchanges. I hope Leng Feihong could continuously work hard, make continuous progress, and grow up constantly, to inherit Chinese culture, tell Chinese stories well, and make due contributions to society.

Tam Yiu Chung

July 2020

序言三

與冷先鋒師傅相識數載，早前他喜孜孜地告訴我，説他的兒子冷飛鴻將會出版一本教授太極拳的書籍，希望我替他撰寫序言，我當然義不容辭。因爲太極拳是我國的國粹之一，非常值得推廣，同時由十歲的小飛鴻出書示範，相信可以帶動小朋友學習太極的風氣，有助扭轉太極拳是只有長者才會參與的形象。

再加詳談后，我才知道原來是新型肺炎疫情成就此書的出版。話說，因疫情停課，小飛鴻希望可以充份善用在家學習之利，來發揚我國的國術，于是便提出希望可以把從冷師傅傳承下來的太極拳，以書傳方式推廣。小飛鴻曾多次到海內外作賽，故是書亦以中英對照發行，目的就是希望把中國的文化傳播開去，讓世界各地的大小朋友，都可以由淺入深地學習太極拳。

冷先鋒師傅，本身爲當代太極拳名家、全國武術太極拳冠軍、香港全港公開太極拳錦標賽冠軍，在内地及本港都有設館授徒，桃李滿門，本身已是信譽保證。而小飛鴻自小已跟着爸爸教拳，幾歲便甚有功架，是不少學員的大師兄。對于小飛鴻的著書大志，我深感欣喜。一方面可以體現中國國粹由父傳子、再推而廣之的美事，另一方面在疫情之下，保持強健的體魄必不可缺。現時不少人都要留家抗疫，而習太極的門坎及對空間的需求不高，正好讓大家即使留在家中，也可與長者及大小朋友一起練習，在強身之余，亦不失爲一家樂聚天倫的上佳活動。

<div align="right">

陳恒鑌

香港立法會議員

2020 年 7 月

</div>

Preface 3

I have known Master Leng Xianfeng for many years. He always assured me that his son Leng Feihong would publish a taiji instruction book, and hoped that I would write a foreword for the book, which of course it is my duty to do. As the essence of Chinese culture, taiji is worthy of promotion. And now, ten-year-old Feihong has published a book of instruction. It is to be hoped that this book may encourage children to learn taiji and help reverse the impression that only the elderly practice taiji.

After more detailed discussion, I realized that it was the new coronavirus epidemic that necessitated publication of this book. In other words, classes having been suspended due to the epidemic, young Feihong hopes to make full use of the benefits of studying at home to promote our country's martial arts, and so promote taiji, as passed down from Master Leng, through books of instruction. Young Feihong has taken part in many competitions at home and abroad, so this book is published in Chinese and in English with the aim of promoting Chinese culture and so that children throughout the world may learn taijiquan step by step.

Leng Xianfeng is a famous taijiquan master, a national wushu taijiquan champion, and champion of the Hong Kong open taiji competition. He has set up schools in mainland china and Hong Kong, whose success is a guarantee of credibility. Feihong has been teaching taijiquan alongside his father since he was a child – though still young, he has achieved great merit, and is a mentor to many older students. I was greatly pleased to hear that Feihong will to publish this book. On the one hand, it reflects the essence of Chinese culture passed from father to son and onwards; on the other hand, under the conditions of the epidemic, keeping fit is indispensable. Many people now have to stay at home to prevent the epidemic, but the requirements for space to study taiji are not great – so one can practice at home with young and old together. In addition to strengthening the body, it is also a great activity for the family to enjoy together.

Ben Chan Han-pan

Member of the Legislative Council

July 2020

序言四

欣聞《國際武術大講堂系列教學》之一《校園太極拳》一書將要出版了，謹此表示熱烈的祝賀！

冷飛鴻小朋友，是我的學生冷先鋒的兒子，非常聰明伶俐，給我留下深刻的印象，特別是他從小就對太極拳有很大的興趣，這在當今的小朋友裏面是不多見的，何況他才十歲。

2019 年 7 月在香港麥花臣體育館舉辦的第二屆世界武術大賽時，我是作為邀請嘉賓擔任大賽仲裁委員會主任，在賽場發現了冷飛鴻，小小年紀，不怯場，動作一招一式，行雲流水，氣定神閑，一點不輸給大人，我就覺得是可塑之才，並當場告訴他父親要好好培養，未來不可限量。

在瞭解之中發現，他不只是普通的興趣愛好，還會主動和大人談論關於太極拳的歷史、流傳、發展以及對身體、對生活的好處，並有自己的見解，因為他本身就在學習太極拳的過程中獲益良多，對身體健康、心態調整、專注學習、與人共處都在他的生活中一一體現。

新冠病毒疫情嚴重影響了全世界人民的健康和生活，太極拳作為非常好的防疫健身運動，老少皆宜，希望得到社會各界人士的支持與認可。此書正趕在疫情期間出版，會更好的將太極拳推廣和普及到校園，讓青少年感受太極拳給人類帶來的好處。

馬春喜

中華武林百傑

中國武術九段

2020 年 6 月

Preface 4

I am very glad to know the book "Campus Taiji", one of "International Wushu Lecture Series", will be published. Here, I send my warm congradulations.

Little friend Leng Feihung, clever and nimble, my student Leng Xianfeng's son, gives me a deep impression. Especially, his being keen on taijiquan as a child, is rare nowadays among children; what is more, he is only ten of age.

As an honourable guest invited, I was the head of arbitration committee of the Second World Martial Arts Competition held at Macpherson Stadium. There I discovered Leng Feihung. He performed clamly every movement and every posture, without stage fright, like flowing clouds and flowing water. He did not lose to any adult the least bit. I believed that he was a boy to be moulded. At once I told his father that he must foster the boy well and his son would have a boundless future.

Having realized more, I have found out that Leng Feihung is not only interested in and fond of taijiquan generally, he also talks with adults actively about taijiquan history, its schools, its development and the benefit to human body and life.Moreover, he has his view: he has gained considerably during practising taijiquan, which embodies in body health, mental adjustment, concentration on study, and coexistence with others.

As the coronavirus pandemic is at present influencing the health and the people all over the world severely, taijiquan is considered very good physical exercise of prevention, suitable for young and old. I hope it will be approved and supported by all fields in society. The publication of the book Campus Taiji will be better for the popularity of taiji to campus, letting the teenagers feel the benefit of taijiquan to mankind.

Ma Chunxi,
China Wulin 100
Chinese Wushu 9th Duan
June, 2020

序言五

冷飛鴻，今年十歲，出生於武術世家，現就讀於香港油蔴地天主教小學（海泓道）五年級。

自幼隨父親冷先鋒、母親鄧敏佳學習武術，因父母都是太極拳名家和冠軍，並在二零零八年被香港特區政府以《香港優秀人才計劃》引進香港，一直以開武館授徒為職業，使得整天在武館長大的飛鴻和妹妹飛彤自小就受武術太極文化的薰陶，四歲就參加香港的武術精英賽，並連續四年獲得少兒組的太極拳冠軍，集體拳術冠軍。

因為他們對武術太極拳有著濃厚的興趣，父母也經常帶他們到世界各地參加武術太極比賽和文化交流，接受各大電視、電臺、報紙媒體的採訪，練就了他超越同年人的睿智和膽量，小小年紀常在父親教課時一邊充當學生還一邊做起了助教，久而久之，父親的弟子們都習慣地稱他為飛鴻師兄（飛鴻哥、小師傅），因為天資聰穎，善於思考，勇於嘗試，在學校各科學習成績、才藝表演、體育田徑等多方面表現都很優異。

儘管如此，可父母還是一直告誡他們要做一個有愛心、謙卑、懂感恩的人。他自己也遵循的父親一直提倡人類健康標準的重要準則："身體健康、身心愉悅、適應社會的能力"，希望為發揚中國傳統文化，構建人類健康共同體這一宏偉目標而不斷努力。

編輯委員會

2020 年 7 月 18 日

Preface 5

Leng Feihung, aged ten, was born into a martial arts aristocratic family. He is a Class Five pupil of Yaumati Catholic Primary School (Hoi Wang Road).

Following his father Leng Xianfeng and mother Deng Minjia, Leng Feihung has practised martial arts since childhood. Having been introduced, his parents, both renowned masters and champions, moved to Hong Kong in 2008 through HKSAR "Quality Migrant Admission Scheme". Since then, they have been running martial arts shops and teaching by profession. All this enables Leng Feihung and his younger sister Leng Feitung to be nurtured every minute in the culture of taiji and martial arts in their young days. Leng Feihung, at four, participated HK elite competitions and held championship four times continuously in children-kids taijiquan competitions and collective boxing competitions.

Since the brother and the sister have keen interest in martial arts and taijiquan, their parents, with them, often participate in martial arts and taijiquan competitions, and cultural exchange activities all over the world, and receive medium interviews of TV, radio and newspapers, so they experience a lot. Leng Feihung's wisdom and courage exceeds much more than the ones of his age. He is not only a pupil, but also an assistant while his father is teaching. In time, he is used to be called Brother Feihung or Littlle Master by his father's followers. Because of being wise, brave to try and good at pondering, at school Leng Feihung is an excellent pupil in all subjects, talent shows and all forms of athletics.

Leng Feihung is advised to be a modest, compassionate, and appreciative person by his parents. He himself also complies with the standard of human health advocated by his father all along: health in body, happiness in mind and adaptability to society. He hopes to work hard on for a grand aim: developing Chinese traditional culture and building a human healthy community.

Editorial Board
July 18, 2020

太極獲獎

2015 沙田武術錦標賽冠軍

2016 年沙田武術錦標賽冠軍

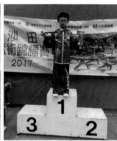
2017 年沙田武術
錦標賽冠軍

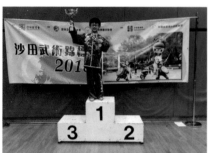
2018 年沙田武術錦標賽冠軍

2019 年第二屆世界武術
大賽全能冠軍（香港）

澳門比賽

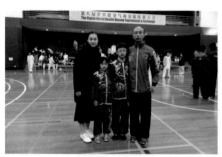
澳洲墨尔本比賽

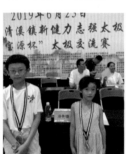
東莞比賽

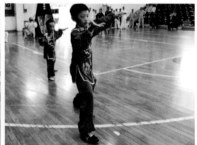
佛山比賽

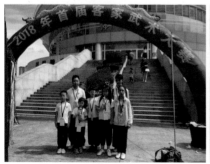
福建比賽

獲得團體冠軍

江門比賽

表演・比賽

 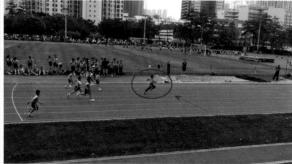

田徑比賽

 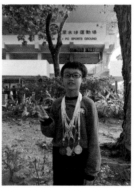

學校合唱團 　　　　　短跑冠軍 　　　　　油蔴地天主教小學
　　　　　　　　　　　　　　　　　　　　（海泓道）學樂器

 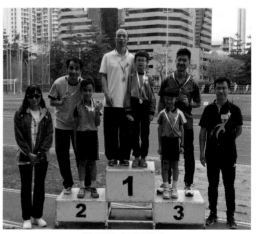

參加合唱表演 　　　　　　　親子接力賽冠軍

海南三亞比賽

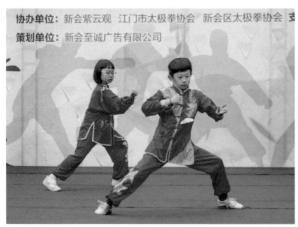

江門比賽

沙田比賽

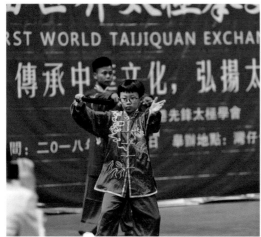

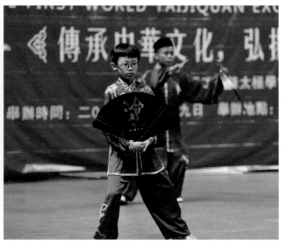

太極拳比賽

香港比賽

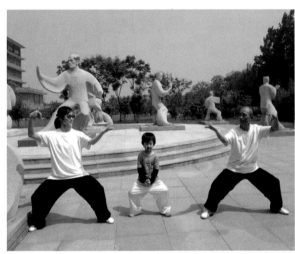

陳家溝學習

陳家溝游學

武打明星梁小龍

練習書法

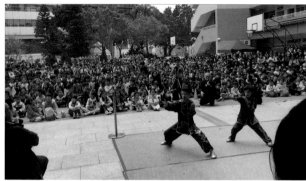

參加學校嘉年華表演　　　　　　　　　　敬老表演

學校表演

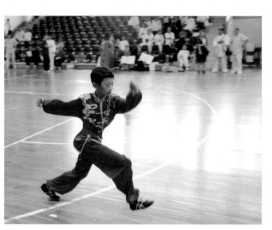

澳大利亞比賽　　　　　　　　　　　佛山比賽

少林寺游學　　　　　　　　在澳洲雪地打拳

小教練

學習

電視電台採訪

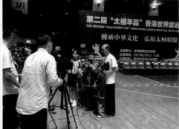

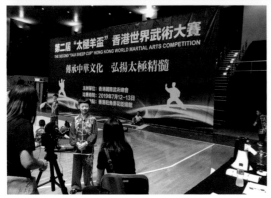

2016.07.31 星期日　　東方日報　　要聞二 A2

河南太極宗師 優才來港當掌門
傳授中庸之道 減壓鍛煉身心

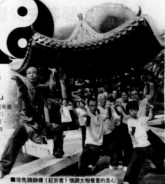

▶冷先鋒師傅（紅衣者）強調太極看重的是心境，故常教導學生「中庸之道」。（胡家豪攝）

【記者新蒲崗報道】拳隨意出、慢中有快、口中唸唸有詞「祖述鄧山、鬆馴操、野馬分鬃」，一班跟隨太極名家冷先鋒的門生正在示範陳式太極拳。太極起源地

■學習太極可令人放鬆及增加專注力。

河南陳家溝，第十一代傳人冷先鋒於八年前以優秀人才計劃申請來港定居，由起初的「一無所有」，到今日桃李滿門，他希望能將太極推廣為「全民運動」，擺脫只是「老人運動」的想法。

組義工隊推廣太極普及化

冷先鋒表示，太極不止是招式，更着重心境，當教導學生「中庸之道」，凡事不要太過分，要取得「陰陽」平衡，他組成義工隊，深遣徒弟到各間老人院傳授技、鍛鍊身體，令太極普及化。眼見小學生因家長及功課壓力過大，他下一步故將太極推廣至小學，令學生懂放鬆及增加專注力。

現年四十歲的冷師傅自八歲起習武，多年來於國內外獲獎無數，廿二歲時開設武館，四年後獲他和家人到深圳發展，他亦為護此逍遙自在，不少港人更專程到深圳跟他學習陳式太極拳。二○○六年本港推行優才計劃，在徒弟游說下，冷師傅抱着申請，兩年後獲港府批准來

港。冷指當年內地經濟比香港差，故決定來港發展以「正宗」太極，現時本港太極水平已進步很多，比內地各省不惶多讓。

來港初期遭人上門「踢館」

「文無第一、武無第二」，冷師傅憶起來港不久即有在港扎根的太極傅找上門「踢館」，他指「對方武功略及我，與我由衷針打，但見我打咁郁就說話『承讓』。」在港初期，冷師傅的生活沒有如外界想像般光鮮，「一無所有」一切都要辛辛用心經營，絕非少許不愉快經歷。但冷師傅認為人生有很多心，徒弟們亦盡心為他的生活籌勞和教他兒童話，令他很快樂很本地生活。他在港渡了好幾年，各徒弟亦賽括多個比賽的冠及亞軍。

太極先鋒 誓圓上市夢
優才來港創運動品牌

太極理念實踐生活
若挫搓挖經難商上

共同嗜好真正親子樂
太極家庭耍出和諧

不少家庭的所謂親子活動，不是爸媽遷就孩子，就是孩子配合爸媽，親子時間是有的，但未必每個家庭成員都能享受其中。著名太極師傅冷先鋒就算是異數，一家四口包括兩名年幼子女都擁有共同興趣——耍太極！顧瑞成章，耍太極就成為冷氏一家最佳的親子節目，「我覺得這樣好，一家人培養相同嗜好，玩起來，大家都能投入。」冷師傅一臉滿足地說。

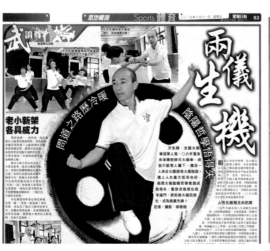

Sports 體育　　一九一六年十一月二十一日 星期五　　東方日報 S2

武 館
兩儀生機
同道之路歷冷暖　陰陽哲學悟得失

老小新榮 各具威力

冷先鋒・全國人氣
拳羽軍人氣・○八年榮獲來港優才資格式太極一屆，初以結交人豬下、貶身一
人亦去全國推廣太極，
他在大陸揚陽哲學推廣化、成為重要的一
李國門，更給俗大極民深

記者、攝影：郭麗麟

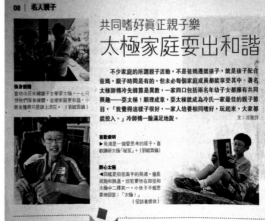

08 | 名人親子
共同嗜好真正親子樂
太極家庭耍出和諧

不少家庭的所謂親子活動，不是爸媽遷就孩子，就是孩子配合爸媽，親子時間是有的，但未必每個家庭成員都能享受其中。著名太極師傅冷先鋒就算是異數，一家四口包括兩名年幼子女都擁有共同興趣——耍太極！顧瑞成章，耍太極就成為冷氏一家最佳的親子節目，「我覺得這樣好，一家人培養相同嗜好，玩起來，大家都能投入。」冷師傅一臉滿足地說。

文：沈施詩

獲獎證書

油蔴地天主教小學(海泓道)
Yaumati Catholic Primary School(Hoi Wang Road)

嘉許狀
Certificate of Appreciation

3B 冷飛鴻

榮獲 2017 - 2018 年度第三段考

班際學業成績獎

殊堪嘉許 特發此狀 以茲鼓勵

二零一八年七月九日

(何綺霞校長)

油蔴地天主教小學(海泓道)
Yaumati Catholic Primary School (Hoi Wang Road)

嘉許狀

3B 班 學生 冷飛鴻

於二零一八年二月三日

擔任「50周年校慶・敬老嘉年華」表演生

熱心服務 謹頒此狀 藉表謝忱

何綺霞校長

二零一八年二月廿六日

油蔴地天主教小學(海泓道)
Yaumati Catholic Primary School (Hoi Wang Road)

茲證明

5D 冷飛鴻

榮獲 2019 - 2020 年度第一學段

Superkids

好學生獎勵計劃
銅獎

殊堪嘉許 特頒此狀 以示鼓勵

陳淑儀校長
11/1/2020

油蔴地天主教小學(海泓道)
Yaumati Catholic Primary School(Hoi Wang Road)

嘉許狀
Certificate of Appreciation

4C 冷飛鴻

榮獲 2018-2019 年度第二學段

常識科
學科成績優異獎

殊堪嘉許 特發此狀 以茲鼓勵

二零一九年四月十六日

(陳淑儀)

校長

油蔴地天主教小學(海泓道)
Yaumati Catholic Primary School(Hoi Wang Road)

茲證明

4C 冷飛鴻

榮獲 2018 - 2019 年度第三學段

Superkids

好學生獎勵計劃
星級學生・1 星獎

殊堪嘉許 特發此狀 以示鼓勵

陳淑儀校長
8/7/2019

油蔴地天主教小學(海泓道)
Yaumati Catholic Primary School (Hoi Wang Road)

嘉許狀
Certificate of Appreciation

3B 冷飛鴻

榮獲 2017-2018 年度第二段考

級際成績獎

殊堪嘉許 特發此狀 以茲鼓勵

二零一八年四月十一日

(何綺霞校長)

油蔴地天主教小學 (海泓道)
YAUMATI CATHOLIC PRIMARY SCHOOL (HOI WANG ROAD)

嘉許狀
CERTIFICATE OF APPRECIATION

Third Place for J.2-3 English Choral Speaking
Awarded to

3B LENG FEI HUNG

at the 69th Hong Kong Schools Speech Festival
in the academic year 2017-2018

Principal Y. H. Ho
13 January 2018

油蔴地天主教小學(海泓道)
Yaumati Catholic Primary School(Hoi Wang Road)

嘉許狀
Certificate of Appreciation

4C 冷飛鴻

榮獲香港學校音樂及朗誦協會主辦

第七十屆香港學校朗誦節

小學三、四年級組散文集誦

亞軍

殊堪嘉許 特發此狀 以茲鼓勵

二零一九年一月十九日

校長

(陳淑儀)

油蔴地天主教小學(海泓道)
Yaumati Catholic Primary School (Hoi Wang Road)

2018-2019 年度

「星光伴我行」
閱讀獎勵計劃

茲證明

4C 班 學生 冷飛鴻

於閱讀活動表現優良

殊堪嘉許 特頒此狀

陳淑儀校長
8-7-2019

2018 "KUNGFUWONG" 杯
大湾区侨乡武术大赛
世界武术日
获奖证书

姓 名：	冷飞鸿
比赛项目：	陈式太极拳
获得奖项：	一等奖
比赛地点：	江门市体育馆

大湾区侨乡武术大赛组委会
2018年8月11日

首届世界大健康運動會
展演證書
the First Session of World Comprehensive
Health Sports Meeting
Performance certificate

冷飛鴻 冷飛彤

第十届澳門國際健康健美容發論壇暨首届世界大健康産業博覽會組委會
The 10th International Health and Longevity Forum, a Health Industry Expo and
the First Session of World Comprehensive Health Sports Meeting
Members of Organizing Committee
Macao,China—April 2018

展演證書

Nº 0000418

东莞市清溪镇
新健力志强太极拳"宝源杯"太极交流赛
获奖证书

参赛单位	香港冷先锋武术学院
竞赛名称	陈式太极拳
运动员姓名	冷飞鸿
名次与成绩	金奖
地点时间	清溪新健力体育中心 2019.6.23

主办单位：东莞市清溪镇新健力志强太极拳馆
指导单位：东莞市武术协会

弘扬 太极 文化 传承 太极 精神

CERTIFICATE
獲獎證書

太極羊盃
第二届香港世界武術大賽

姓名：	冷飛鴻
項目：	32式太極劍
成績：	冠軍

香港國際武術總會
2019年7月12—13日

獲獎證書
AWARD CERTIFICATE

首届世界太極拳交流大會
THE FIRST WORLD TAIJIQUAN EXCHANGE CONFERENCE

姓 名： NAME	冷飛鴻
項 目： PROJECT	陈式太极拳
成 績： RESULTS	一等奖

中国·香港 2018年6月19日

The 8ᵗʰ World Health Qigong
Tournament and Exchange
第八届世界健身气功交流比赛大会
11-12 August 2019 - Melbourne, Australia
2019 年 8 月 11 日至 12 日 澳大利亚 墨尔本

AWARD CERTIFICATE
获奖证书

Leng Fei Hung 冷飞鸿

BA DUAN JIN

1st Prize

國際健身氣功聯合會
International Health Qigong Federation

CERTIFICATE
獲獎證書

太極羊盃
第二届香港世界武術大賽

姓名：	冷飛鴻
項目：	陈式太极拳
成績：	冠軍

香港國際武術總會
2019年7月12—13日

2019 第二届
2019 INTERNATIONAL
日本德島国際武術交流大会
Japan Tokushima International Wushu Friendly Match
成績証書
Certificate of Achievement

陈式太極拳男子A組　　　第一位

冷飛鴻 殿

あなたは日本德島国際武術交流
大会において頭書の成績を収め
られたのでこれを賞します
I will prize for keeping the results at Japan Tokushima
International Wushu Friendly Match.

2019年 12月1日

大会名誉会長	大会仲裁委員会主任
德島県知事	中国武術研究専門家委員会主任
飯泉嘉門	張山

大会総審判長
德州市武管中心武术运动管理主任
張杕

"三亚南山"第二届世界太极文化节
Sanya Nanshan 2nd World Tai Ji Culture Festival
世界太极交流大赛
The World Tai Chi Exchange Competition
获奖证书
Honor Certificates

冷飞鸿　　：

在"三亚南山"第二届世界太极文化节
世界太极交流大赛中，获得集体太极拳器械
项目　　一等奖。

世界太极文化节组委会
2017年9月

証書

冷飛鴻 于2014年4月30日至5月3日參加焦作市非物質文化遺產保護中心、溫縣文化廣電新聞出版局、溫縣體育局主辦，陳家溝太極拳研究院、溫縣世通太極研究會承辦的太極拳名家大講堂—陳軍團老架一路拆拳講勁培訓班，經考核成績合格，特發此証。

老師簽名：
陳世通 陳軍團

溫縣世通太極拳研究會
二〇一四年五月三日

証書

冷飛鴻 于2015年5月1日至5月4日參加焦作市非物質文化遺產保護中心、溫縣文化廣電新聞出版局、溫縣體育局主辦，陳家溝太極拳研究院、溫縣世通太極研究會承辦的太極拳名家大講堂—陳軍團老架一路精修班，經考核成績合格，特發此証。

老師簽名：
陳世通 陳軍團

陳家溝太極拳研究院 溫縣世通太極研究會
二〇一五年五月四日

油蔴地天主教小學(海泓道)

17-18 年度

為校爭光榮譽獎

榮獲 銅 章乙枚

項目：69th Hong Kong Schools Speech Festival
Choral Speaking Primary 2-3 Mixed Voice

獎項：3rd Place

班別：3B

姓名：LENG FEI HUNG

油蔴地天主教小學(海泓道)

18-19 年度 第一學段

為校爭光

榮獲 銀 章乙枚

項目名稱：第七十屆香港學校朗誦節
三四年級粵語散文集誦

獎項：亞軍

班別：4C

姓名：冷飛鴻

CERTIFICATE OF INVESTITURE

香港童軍總會九龍第1326旅
Scout Association of Hong Kong 1326th Kowloon

小童軍誓詞
我願參加小童軍 愛神愛人愛國家

品德證明
冷飛鴻
豆智成為 小童軍

This is to certify that Leng Fei Hung

The Grasshopper Scout Promise
I promise to be a Grasshopper Scout, to love God
to love people and to love country.

Has made the Promise and was invested
As a Grasshopper Scout

領導木
小童軍領袖 MONG Sau-ting
Grasshopper Scout Leader

關丌童
旅長 LAI Yuet-so
Group Scout Leader

簽發 出發日 Date: 8-11-2014 編號 No.: 1326/436/2014

香港兒童棋院
HONG KONG CHILDREN'S GO COLLEGE

圍棋証書
GO (wei qi) Certificate

茲証明
We certify that

冷飛鴻

已完成 _____初階_____ 班課程並取得優異成績。
is Completed the Elementary 1 Course
and Got Excellent Result.

28-05-2016
簽發日期
Date of Issue

院長 敖立賢 專業四段
Ao Li Xian Pro. 4 Dan

天主教進教之佑堂
Mary Help of Christians Parish

義工感謝狀

茲證明

冷飛鴻 同學

於二零一五年十二月十三日
探訪何文田區獨居長者活動
特頒此狀 以茲嘉許

謝家賢 神父
主任司鐸

香港兒童棋院
HONG KONG CHILDREN'S GO COLLEGE

圍棋証書
GO (wei qi) Certificate

茲証明
We certify that

冷飛鴻

已完成 _____初級_____ 班課程並取得優異成績。
is Completed the Elementary Course
and Got Excellent Result.

23-01-2016
簽發日期
Date of issue

院長 敖立賢 專業四段
Ao Li Xian Pro. 4 Dan
Principal

荣誉证书
HONORARY CREDENTIAL

冷飞鸿：

你在"加油中国，祈福武汉"节目展演活动中，表现优异，成绩突出，获得"爱心大使"荣誉称号，愿您继续关注公益活动。

北京乐陶文化艺术节组委会
2020 年 06 月

获奖证书
Certificate of Award

冷飞鸿 同学：

在《中国少年儿童美术书法摄影作品》（第21卷）暨 2018 "华蓥儿艺"全国少年儿童美术书法摄影大赛征稿活动中，你的作品荣获 美术贰等 奖，并获�傅画集入选资格。

特颁此证，以兹表彰

第十九届
深圳市传统武术精英赛

奖状

运动员姓名： 冷飞鸿 2102

代 表 队： 香港冷光晖武术学院有限公司《陈式太极拳》

参赛项目： 陈式太极拳

名次/等奖： 一等奖

深圳市武术协会
2017年11月25、26日

2020年首届中英健身气功
1ST CHINA-UK HEALTH QIGONG BADUANJIN VIDEO COMPETITION 2020
网络视频系列大赛之八段锦

获奖证书
ACHIEVEMENT CERTIFICATE

冷飞鸿 (先生/女士)

荣获八段锦 健康盎星赛

特发此证，以资鼓励

Star Child award
The Health and Longevity Certificate is awarded to FEIHONG LENG for active participation in Health Qigong Baduanjin.

英国健身气功协会
British Health Qigong Association

2019 第二回
日本德島国際武術交流大会
Japan Tokushima International Wushu Friendly Match

成績証書
Certificate of Achievement

陳式太極扇男子A組 　　第一位

冷飛鴻 殿

あなたは日本德島国際武術交流大会において頭書の成績を収められたのでこれを賞します

I will prize for keeping the results at Japan Tokushima International Wushu Friendly Match.

2019年12月1日

拉斐爾美術學院
Raphael Art Centre

Certificate

This is to certify that

冷飛鴻

has completed 綜合視覺藝術課程

From (27/02/2016 To 28/05/2016)

and

is hereby awarded this certificate.

Raphael art centre　　　　(1/06/2016
　　　　　　　　　　　　　　Date

CAMBRIDGE ENGLISH
Language Assessment
Part of the University of Cambridge

Cambridge English
Starters
Cambridge Young Learners English (YLE) Starters

FEI HUNG LENG
took YLE Starters
in APRIL 2015
in Hong Kong

and was awarded the following:

Reading and Writing

Listening

Speaking

Saul Nassé
Chief Executive

Cambridge English
Young Learners

Trinity College London
Leng Fei Hung Lenny

student at Monkey Tree English Learning Center
is awarded

Grade 1
Graded Examination in Spoken English
Certificate in ESOL International
(Speaking and Listening)

Monkey Tree English Learning Center · December 2014
Certificate issued 19 January 2015

TRINITY
COLLEGE LONDON

目 錄
DIRECTORY

注釋：

白：代表左腳，黑：代表右腳

表示前腳掌着地。

表示腳跟着地。

表示其中一只腳懸空的動作。

代表右手右腳路綫

代表左手左腳路綫

1
（一）起勢
1.Opening form

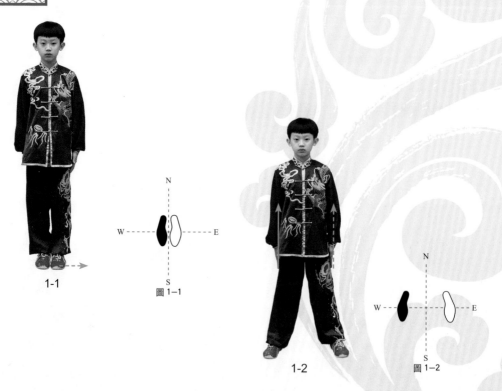

1-1

圖 1−1

1-2

圖 1−2

1 **並腳直立** 身體自然直立，兩手鬆垂輕貼大腿外側，目視正前方（以正前方是正南面）（圖 1−1）；

a. Stand upright feet together – body naturally upright, arms relaxed with palms resting lightly on outside of thighs, look straight ahead (straight ahead is "south" on the compass);

2 **開步肩寬** 左腳向左橫開一步，與肩同寬（圖 1−2）；

b. Step shoulder width apart – move left foot one step to the left, shoulder width apart;

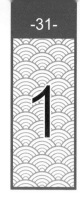

（一）起勢
1.Opening form

圖 1-3

圖 1-4

3 **兩臂平舉** 兩臂向前、向上慢慢平舉，與肩同高，力點在兩手前臂（圖 1-3）；

c. Raise arms to level – arms facing forwards, slowly raise to shoulder level, point of force in each forearm;

4 **屈膝下按** 屈膝鬆肩鬆胯，兩手向下按掌，微微坐腕，力達掌根，目視前下方（圖 1-4）。

d. Bend knees press down – bend knees, relax shoulders, relax hips, press down with both palms, slightly bending wrist, look ahead and down.

2

（二）右金剛搗碓

2.Guardian Pounds Mortar (Right Side)

2-1

圖 2-1

2-2

圖 2-2

1 **左轉掤臂** 身體左轉，重心微偏右，兩臂向左掤出，掌心朝外，與肩同高，力達掌根，目視左前方（圖 2-1）；

a. Left turn lift arms – turn body left, shift weight slightly right, lift arms out to the left, palms facing outwards, to shoulder level, force expressed through base of palms, look to left and forwards;

2 **右轉平捋** 身體右轉，重心左移，兩臂螺旋向右平捋，掌心向外，同時右腳尖外擺，目視兩掌方向（圖 2-2）；

b. Right turn pull level – turn body right, shift weight left, arms spiral and pull level to the right, palms facing outwards, at the same time swing right toe outwards, look in direction of the palms;

（二）右金剛搗碓

2. Guardian Pounds Mortar (Right Side)

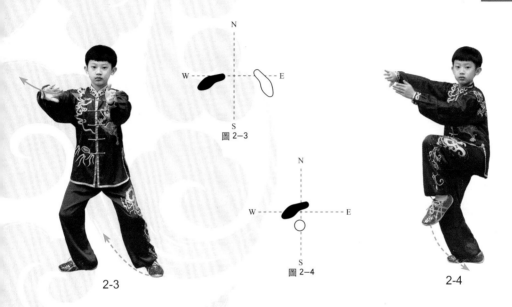

圖 2-3

圖 2-4

2-3

2-4

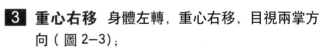

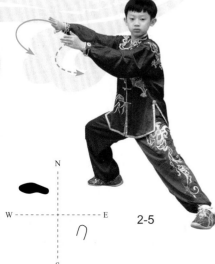

2-5

圖 2-5

3 **重心右移** 身體左轉，重心右移，目視兩掌方向（圖 2-3）；

c. Shift weight right – turn body left, shift weight right, look in direction of the palms;

4 **擦腳平推** 提左腳向左前方擦出，同時兩掌向右后方平推，力達掌根，目視左腳方向（圖 2-4；2-5）；

d. Slide foot push level – lift left foot and slide out to the front and left, at the same time push palms level to the right and rear, look in direction of left foot;

2

（二）右金剛搗碓

2.Guardian Pounds Mortar (Right Side)

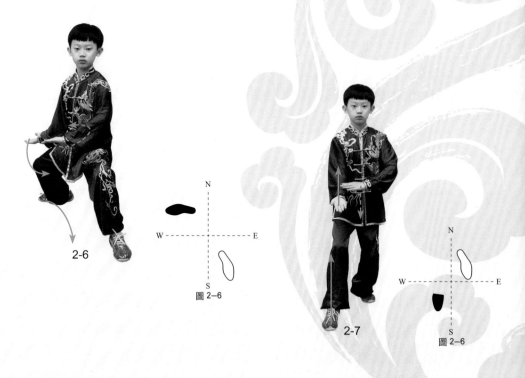

2-6

圖 2–6

2-7

圖 2–6

5 **旋掌鬆胯** 左轉，重心左移，鬆胯旋掌，襠走下弧，目視兩掌方向（圖 2–6）；

e. Swing palms relax hips – turn body left, shift weight left, relax hips swing palms, dip pelvis in a downward arc, look in direction of the palms;

6 **虛步撩掌** 右腳走內弧向前上步，腳尖點地成虛步，同時左手先曲肘再撩掌，右掌前撩和左掌相搭，目視右掌方向（圖 2–7）；

f. Empty stance flick palm – step right foot forward in an inward arc, rest on tips of toes and adopt empty stance, at the same time with left elbow bent flick left palm, flick right palm forward and bring left palm to meet it, look in direction of right palm;

（二） 右金剛搗碓

2.Guardian Pounds Mortar (Right Side)

2

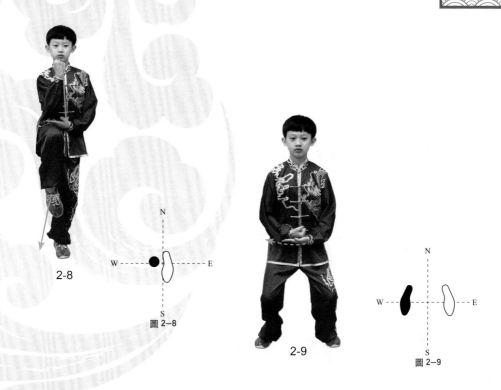

2-8

圖 2-8

2-9

圖 2-9

7 **舉拳提膝** 右掌變拳微下沉再上舉，與鼻同高，左掌收至腹前，掌心向上，同時提右膝，高過水平，腳尖下垂，目視前方（圖 2-8）；

g. Raise fist lift knee – right palm becomes fist, dip slightly before raising to nose level, draw left palm in front of belly, palm facing upwards, at the same time lift right knee, higher than level, toes hanging down, look ahead;

8 **震腳砸拳** 右腳下震，與肩同寬，重心偏左腳，兩腳平行，同時右拳以拳背砸于左掌上，目視前方（圖 2-9）。

h. Thud foot pound fist – drop right foot with a thud, shoulder width apart, weight slightly left, feet parallel, at the same time pound back of right fist onto left palm, look ahead.

35

3

（三）攬紮衣
3.Fasten coat

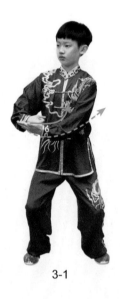

3-1

圖 3-1；3-2

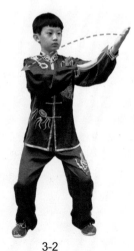

3-2

1 **左轉托拳** 身體微右轉再左轉，重心先右移再左移，向左向上托拳，目視托拳方向（圖 3-1；3-2）；

a. Turn left fist-on-palm – turn body slightly right then left, shift weight first right then left, lift fist-on-palm left and upwards, look in direction of fist-on-palm;

（三）攬紮衣
3.Fasten coat

3

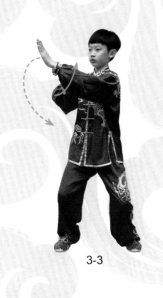

3-3

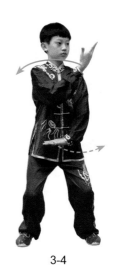

3-4

N
|
W ---●--- E
|
S

圖 3–3；3–4；3–5

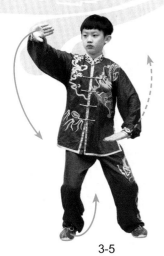

3-5

2 **變掌分開** 身體右轉，重心右移，右拳變掌，劃弧分開，目視右掌方向（圖 3–3；3–4；3–5）；

b. Make palm and separate – turn body right, shift weight right, right fist becomes palm, draw an arc and separate, look in direction of right palm;

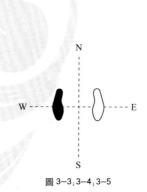

3

（三）攬紮衣

3.Fasten coat

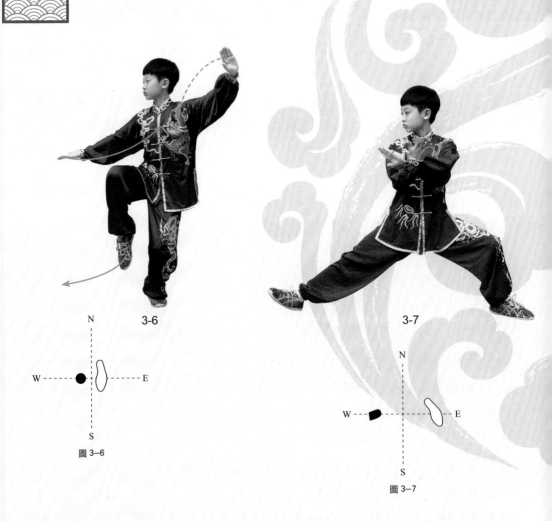

3-6

圖 3-6

3-7

圖 3-7

3 **擦腳合臂** 身體右轉，重心左移，提右腳向右擦腳，同時兩臂劃弧相
合，右臂在外，目視右腳方向（圖 3-6；3-7）；

c. Slide foot close arms – turn body right, shift weight left, lift right foot
and slide to the right, at the same time arms draw an arc and come
together, right arm on the outside, look ahead to the right foot;

（三）攬紮衣

3.Fasten coat

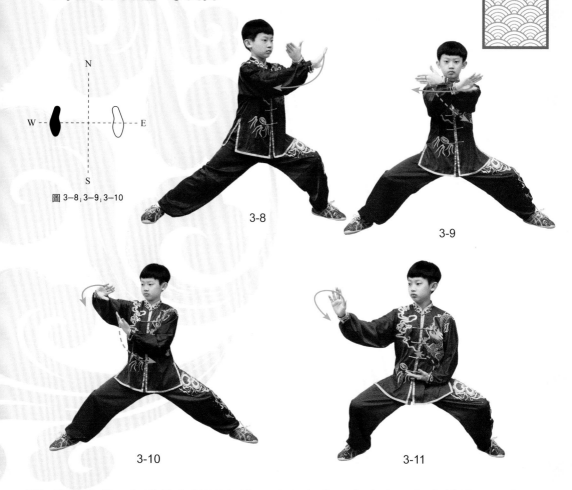

圖 3—8；3—9；3—10

3-8

3-9

3-10

3-11

4 **橫拉立掌**　身體微左轉再右轉，重心右移，右掌內旋向右橫拉，立掌，力達掌根，同時左掌外旋收至腹前，掌心向上，成右偏馬步，目視右掌方向（圖 3—8；3—9；3—10；3—11）。

d. Draw across palm upright – turn body slightly left then right, shift weight right, rotate right palm inwards and draw across to the right, turn palm upright, force expressed through base of palm, at the same time rotate left palm outwards and draw in front of belly, shift weight right, adopt a right-biased horse stance, look in direction of right palm.

4

（四）右六封四閉

4.Six Sealing and Four Closing (Right Side)

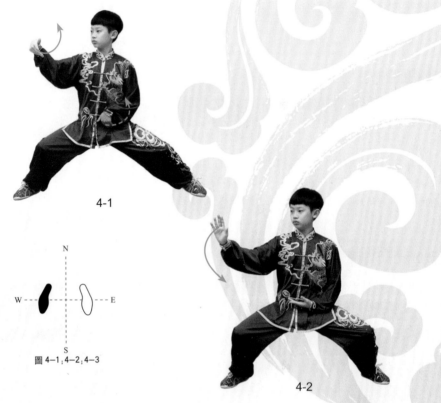

4-1

圖 4-1；4-2；4-3

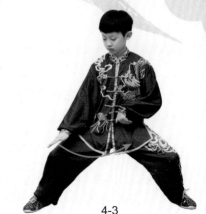

4-2

4-3

1 **轉體旋腕** 身體左轉再右轉，重心左移再右移，同時兩手腕外旋，目視右掌方向（圖 4-1；4-2）；

a. Turn body rotate wrists – turn body left then right, shift weight left then right, at the same time rotate wrists outwards, look in direction of right palm;

（四）右六封四閉

4. Six Sealing and Four Closing (Right Side)

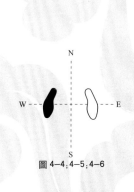

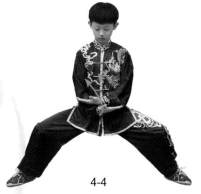

圖 4−4，4−5，4−6

4-4

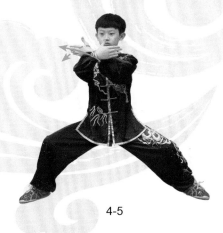

4-5

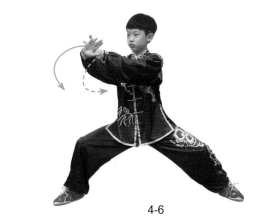

4-6

2 **下捋掤擠** 身體左轉，重心左移，右手向左下捋，同時左掌外旋與右臂相搭，掌心向內，重心右移，兩臂向前向右掤出，右臂內旋，掌心向外，有擠之意，目視兩臂方向（圖 4−3；4−4；4−5；4−6）；

b. Pull down lift push – turn body left, shift weight left, pull right hand down to the left, at the same time rotate left hand outwards and bring right hand to meet it, palm facing inwards, shift weight right, lift arms outwards to the front and right, rotate right arm inwards, palm facing outwards, as if in a crowd, look in direction of the arms;

4 （四）右六封四閉

4.Six Sealing and Four Closing (Right Side)

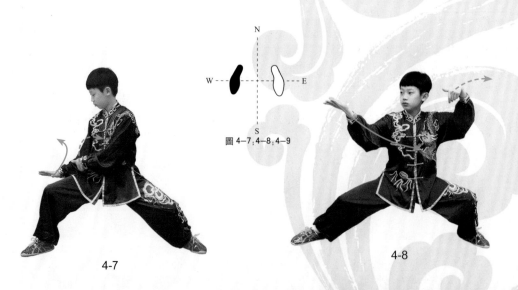

圖 4－7；4－8；4－9

4-7

4-8

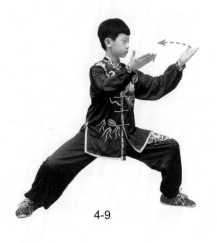

4-9

3 **左刁右托** 身體先右轉再左轉，重心左移，同時兩臂向右劃弧下采，向左、向上刁托，左掌變刁手于左耳側，右手劃弧托掌于右肩前，目視右掌方向（圖 4－7；4－8）；

c. Left grip right lift – turn body first right then left, shift weight left, at the same time draw arms in an arc and pull down, grip and lift left and upwards, left hand grip beside left ear, right hand lift to front of right shoulder, look in direction of right palm;

（四）右六封四閉

4.Six Sealing and Four Closing (Right Side)

4 **左轉旋掌** 身體左轉，兩臂螺旋相合于左耳側，目視兩掌方向（圖4-9；4-10）；

d. Left turn rotate palm – turn body left, arms spiral and come together beside left ear, look in direction of the palms;

圖4-10

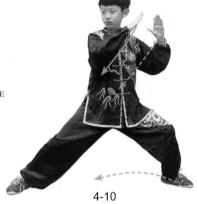

4-10

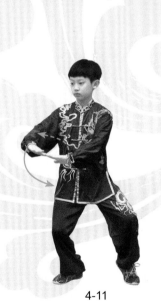

4-11

圖4-11

5 **虛步按掌** 身體右轉，重心右移，兩掌向右、向下按掌，同時左腳收至右腳內側，成虛步，目視兩掌方向（圖4-11）。

e. Empty stance press palms – turn body right, shift weight right, palms to right, press palms down, at the same time bring left foot to inside of right foot, look in direction of the palms.

5 （五）左單鞭
5.Single Whip（Left Side）

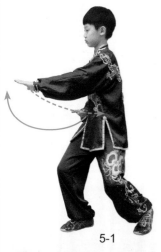

5-1

1 **右轉推收** 身體右轉，左掌向前下方推壓，右手回收和左手形成對拉，目視左掌方向；（图 5-1）；

a. Right turn push pull – turn body right, push left hand forwards and downwards and pull right hand back, the two hands an opposing pair, look in direction of left hand;

2 **左轉提勾** 身體左轉，右掌變勾手，向右前方頂出，以腕部爲力點，同時左掌收至腹前，掌心向上，目視右勾手方向（圖 5-2；5-3）；

b. Left turn rising hook – turn body left, right palm becomes hook, push upwards and outwards to front and right, point of force in the wrist, at the same time draw left hand in front of belly, palm facing upwards, look in direction of right hook;

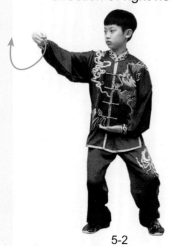

5-2

N

W — — — — — — — E

S

圖 5-1；5-2；5-3

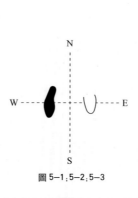

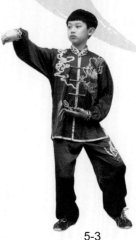

5-3

（五）左單鞭
5.Single Whip（Left Side）

3 **屈膝擦腳** 右腳屈膝，提左腳向左擦出，目視左腳方
向（圖 5-4；5-5；5-6）；

c. Bend knee slide foot – bend right knee, lift left foot
and slide out to the left, look in direction of left foot;

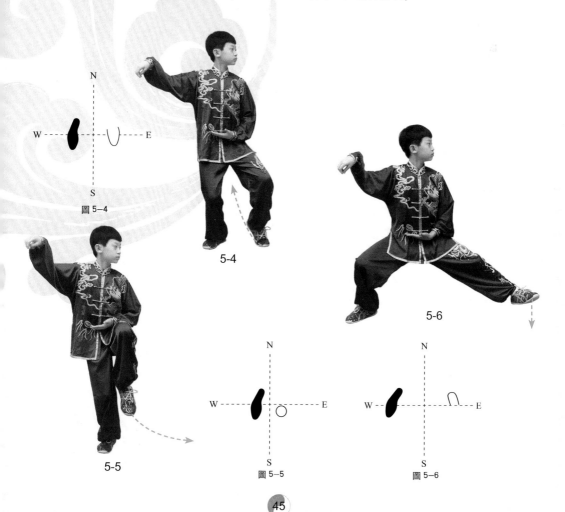

圖 5-4

5-4

5-5

圖 5-5

5-6

圖 5-6

5

（五）左單鞭
5.Single Whip（Left Side）

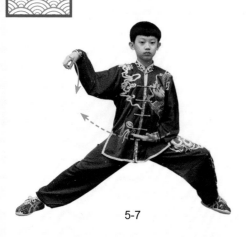

5-7

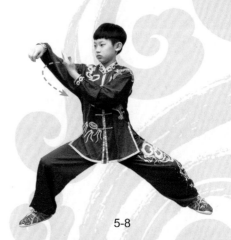

5-8

4 **重心左移** 身體左轉，重心左移，襠走下弧，目視前方（圖5—7）；

d. Shift weight left – turn body left, shift weight left, dip pelvis in a downward arc, look ahead;

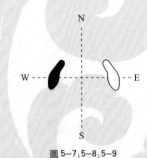

圖 5—7；5—8；5—9

5 **右移穿掌** 身體右轉，重心右移，左掌向右勾手方向穿出，目視左掌方向（圖5—8）；

e. Shift right cross palms – turn body right, shift weight right, left palm crosses over right hook, look in direction of left hand;

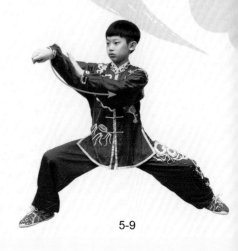

5-9

（五）左單鞭
5.Single Whip（Left Side）

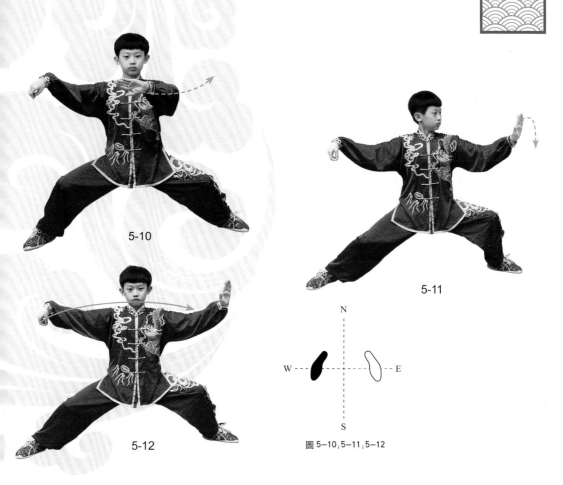

5-10

5-11

5-12

圖 5–10；5–11；5–12

6 **橫拉立掌** 身體左轉，重心左移，同時左掌內旋，向左橫拉，立掌，成左偏馬步，目視前方（圖 5–9；5–10；5–11；5–12）。

f. Draw across palm upright – turn body left, shift weight left, at the same time rotate left palm inwards, draw across to the left, turn palm upright, adopt a left-biased horse stance, look ahead.

（六）搬攔捶
6.Block，Parry，Punch

1 **劃弧變拳** 身體左轉，重心先左移再右移，同時兩掌變拳，逆時針劃弧，先向左再向右，收至右胯旁，拳眼向后，目視右拳方向（圖6-1；6-2；6-3）；

a. Draw arc make fists – turn body left, shift weight first left then right, at the same time palms become fists, arcing counterclockwise, first left then right, draw to right of waist, fist-eye backwards, look in direction of right fist;

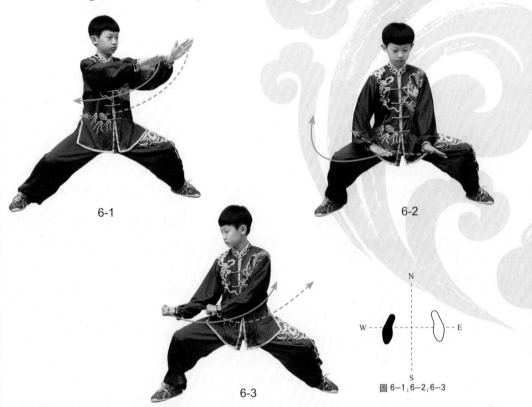

6-1

6-2

6-3

圖 6-1；6-2；6-3

2 **左轉橫擊** 身體左轉，重心左移，兩拳向左后方橫擊，拳眼向后，目視左拳方向（圖6-4）；

b. Left turn strike across – turn body left, shift weight left, fists strike across to left and rear, fist-eye backwards, look in direction of left fist;

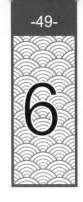

（六）搬攔捶
6.Block，Parry，Punch

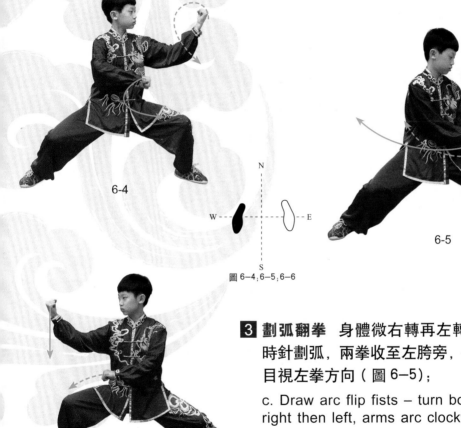

6-4

6-5

圖 6—4；6—5；6—6

6-6

3 **劃弧翻拳** 身體微右轉再左轉，兩臂順時針劃弧，兩拳收至左胯旁，拳眼向后，目視左拳方向（圖 6—5）；

c. Draw arc flip fists – turn body slightly right then left, arms arc clockwise, draw fists to left of waist, look in direction of left fist;

4 **右轉橫擊** 身體右轉，重心右移，兩拳向右后方橫擊，拳眼向后，目視右拳方向（圖 6—6）。

d. Right turn strike across – turn body right, shift weight right, fists strike across to right and rear, fist-eye backwards, look in direction of right fist.

7

（七）護心捶
7.Protect heart with fists

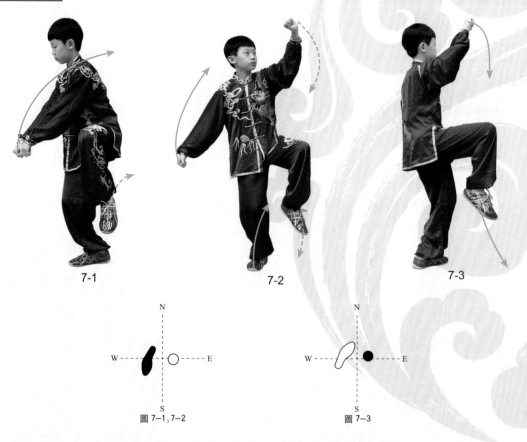

7-1　　　　　　　7-2　　　　　　　7-3

圖 7-1 ; 7-2　　　　　圖 7-3

1 **右轉栽拳** 身體右轉，兩拳向右后方下栽，目視兩拳方向（圖 7-1）；

a. Right turn plant fists – turn body right, plant fists downwards to the right and rear, look in direction of the fists;

2 **躍轉掄臂** 提左膝，右腳蹬地躍起，兩臂掄轉，目視左拳方向（圖 7-2 ; 7-3）；

b. Twist jump swing arms – raise left knee, drive and leap from right foot, swing arms around, look in direction of left fist;

（七）護心捶

7.Protect heart with fists

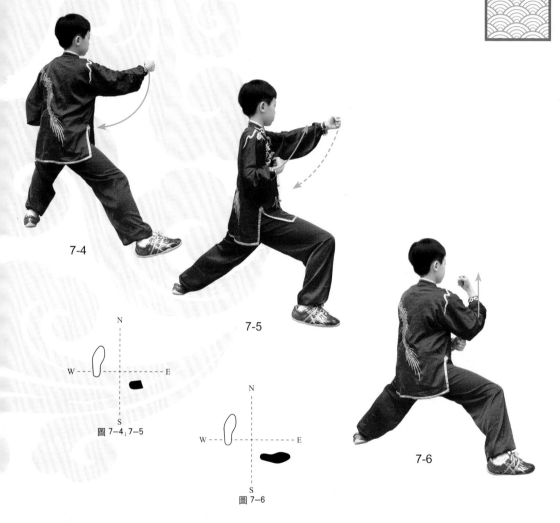

7-4

7-5

圖 7-4；7-5

圖 7-6

7-6

3 **劃弧合臂**　跳至東北方向，身體右轉再左轉，重心右移，兩臂相合發力，右臂在上，力點在右前臂，成右偏馬步，目視前方（圖7-4；7-5；7-6；7-7）；

c. Draw arc close arms – land facing north-east, turn body right then left, shift weight right, arms come together expressing force, right arm uppermost, point of force on right forearm, adopt a right-biased horse stance, look ahead;

7 （七）護心捶

7.Protect heart with fists

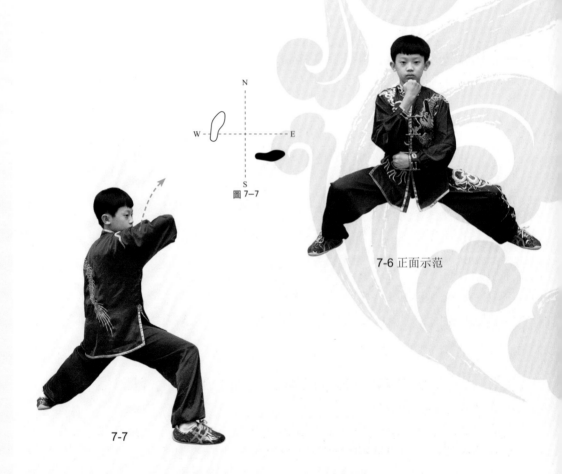

圖 7–7

7-6 正面示范

7-7

4 **右肘上挑** 重心不變，右肘上挑發力，目視右肘方向（圖 7–8）。

d. Right elbow upward strike – weight unchanged, lift right elbow upwards and strike upwards expressing force, look in direction of right elbow.

（八）白鶴亮翅
8.White Crane Flashes its Wings

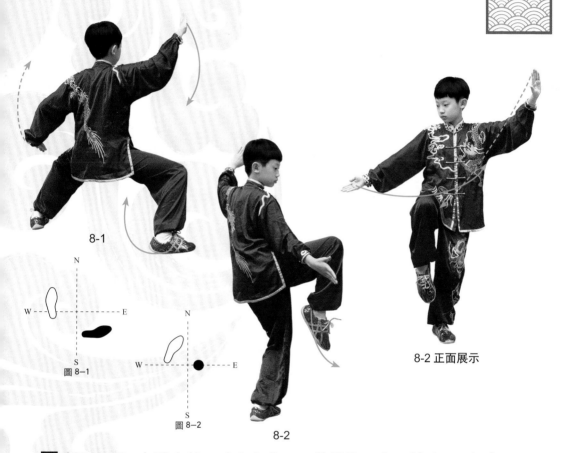

8-1

圖 8−1

圖 8−2

8-2

8-2 正面展示

1 **劃弧分掌** 身體右轉，重心左移，兩拳變掌，分開劃弧，目視右手方向（圖 8−1）；

a. Palms arc apart – turn body right, shift weight left, fist become palms, arc apart, look in direction of right hand;

2 **擦腳合臂** 身體左轉，提右腳，向右前方擦出，兩臂相合，右臂在下，目視右腳方向（圖 8−2；8−3）；

b. Slide foot close arms – turn body left, lift right foot, slide out to right and front, arms come together, right arm below, look in direction of right foot;

8

（八）白鶴亮翅
8.White Crane Flashes its Wings

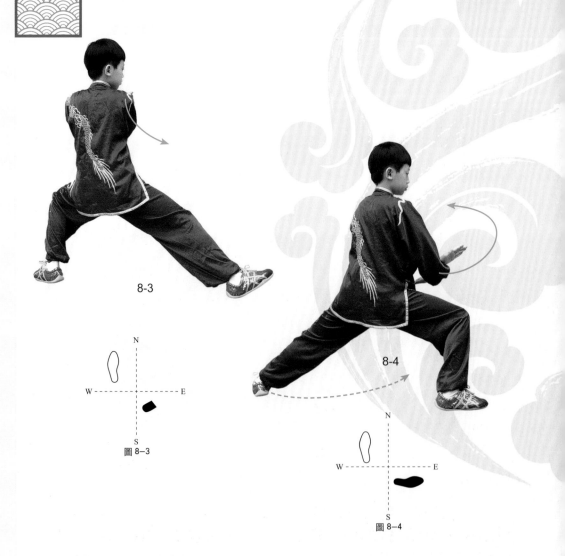

8-3

8-4

圖 8-3

圖 8-4

3 **轉腰旋掌** 身體右轉再左轉,重心右移再左移,兩掌逆時針旋轉一圈, 目視兩手方向（圖 8-4）；

c. Turn waist circle arms – turn body right then left, shift weight right then left, rotate palms counterclockwise a full circle, look in direction of the hands;

（八）白鶴亮翅
8.White Crane Flashes its Wings

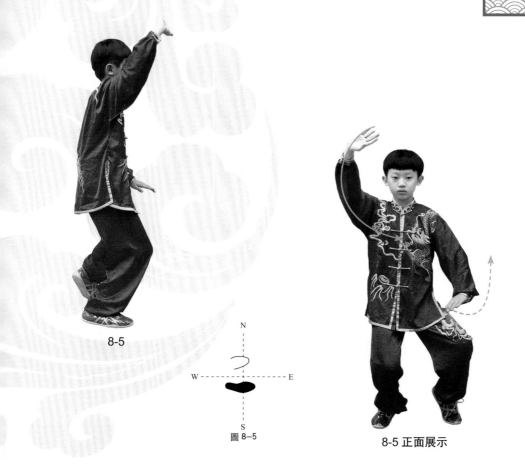

8-5

圖 8-5

8-5 正面展示

4 **收腳分掌** 身體右轉，重心右移，兩掌上下斜分，右掌在右額斜上方，掌心向外，左掌收至左膝上方，掌心向下，同時左腳收至右腳內側，成虛步，目視前方（圖 8-5）。

d. Close feet part palms – turn body right, shift weight right, two palms separate diagonally up and down,right palm to the upper right of the forehead, palm facing outwards, draw left palm above left knee, palm facing downwards, at the same time draw left foot to inside of right foot, adopt an empty stance, look ahead.

（九）斜行拗步
9.Oblique Stance with Twist Step

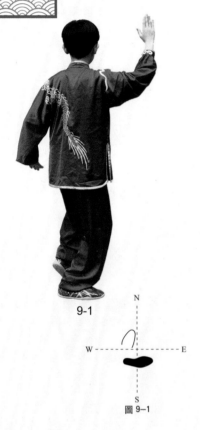

9-1

圖 9-1

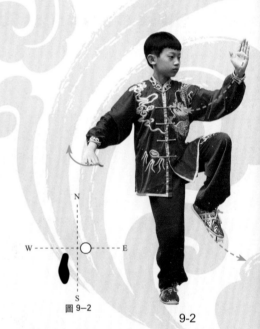

9-2

圖 9-2

1 左轉擺掌 身體左轉，右掌向左撥擋，左掌隨腰轉至左胯旁，目視右掌方向（圖 9-1）；

a. Left turn swing palm – turn body left, right palm push left and block, left palm follows beside hip as waist turns left, look in direction of right palm;

2 右轉提膝 身體右轉，提左膝，左掌向右撥擋，右掌隨腰轉至右胯旁，目視左掌方向（圖 9-2）；

b. Right turn lift knee – turn body right, lift left knee, left palm push right and block, right palm follows beside hip as waist turns right, look in direction of left palm;

（九）斜行拗步
9.Oblique Stance with Twist Step

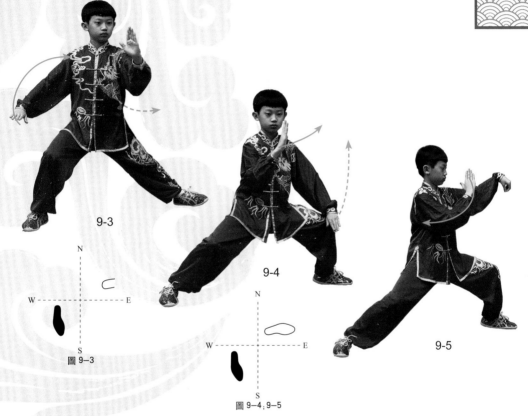

9-3

圖 9-3

9-4

圖 9-4；9-5

9-5

3 擦腳推掌 身體繼續右轉，同時左腳向左前方擦出，左掌向前推出，力達掌根，右掌摟膝收至右胯旁，目視左掌方向（圖 9-3）；

c. Slide foot push palm – continue turning right, at the same time slide left foot out to left and front, push left palm out to front, expressing force through base of palm, look in direction of left palm;

4 左轉提勾 身體左轉，重心左移，左掌向左摟膝變勾手，右掌經耳側向左推出，目視右掌方向（圖 9-4；9-5）；

d. Turn left raise hook – turn body left, shift weight left, draw left palm left and form hook, push right palm past ear out to left, look in direction of right palm;

9 （九）斜行拗步
9.Oblique Stance with Twist Step

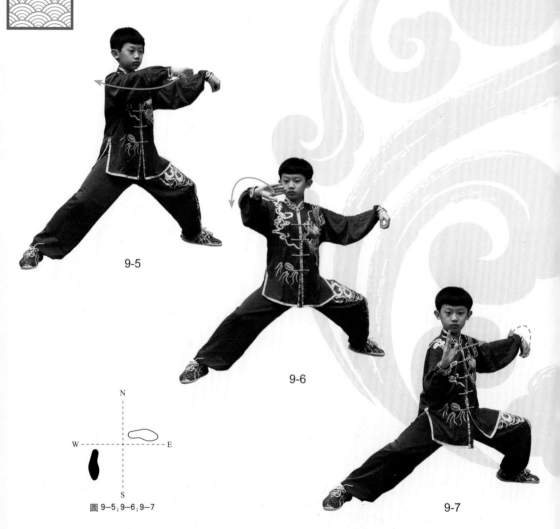

9-5

9-6

9-7

圖 9–5；9–6；9–7

5 **弓步立掌** 身體右轉，重心不移，成左弓步，右掌向右橫拉，立掌，目視右掌方向（圖 9–5；9–6；9–7）。

e. Bow stance palm upright – turn body right, do not shift weight, adopt left bow stance, draw right palm across to the right, turn palm upright, look in direction of right palm.

9

（十）提收
10.Lift and retract

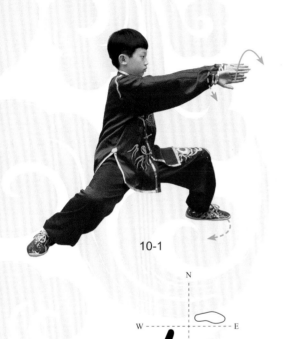

10-1

図 10-1 ; 10-2

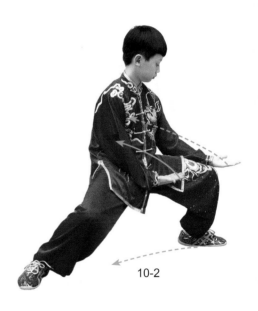

10-2

1 **右移合臂** 身體左轉，重心右移，同時左勾手變掌，兩掌相合，手背相對，目視兩掌方向（圖 10-1）；

a. Shift right close arms – turn body left, shift weight right, at the same time left hook becomes palm, the two palms close together, backs of hands facing each other, look in direction of the palms;

2 **左移合臂** 重心左移，兩臂翻轉，掌心相對，目視兩掌方向（圖 10-2）；

b. Shift left close arms – shift body left, flip both arms, palms facing each other, look in direction of the two palms;

10 （十）提收
10.Lift and retract

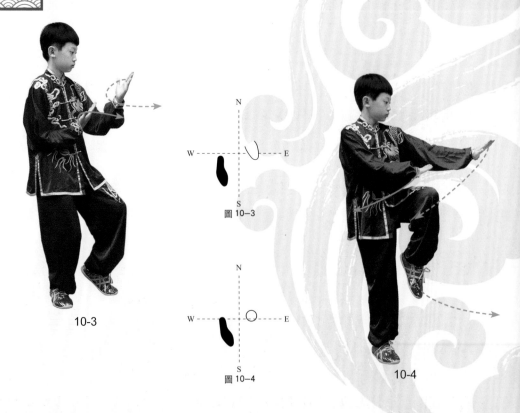

10-3

圖 10-3

圖 10-4

10-4

3 **收掌收腳** 身體右轉，重心右移，左腳收至右腳內側，兩掌同時收至胸前，掌心向內，目視兩掌方向（圖 10-3）；

c. Draw palms draw foot – turn body right, shift weight right, draw left foot to inside of right foot, draw hands together to chest, palms facing inwards, look in direction of the palms;

4 **提膝推按** 身體左轉，提左膝，同時兩掌翻轉，向前下方推按，目視兩掌方向（圖 10-4）。

d. Lift knee press down – turn body left, lift left knee, at the same time flip both palms, press forwards and downwards, look in direction of the palms.

（十一）前趟

11. Wade Forward

圖 11-1

圖 11-1

圖 11-2

圖 11-2

1 **屈膝擦腳** 身體右轉，右腳屈膝，左腳向左前方擦出，同時兩掌向右后方下捋，目視兩掌方向（圖 11-1）；

a. Bend knee slide foot – turn right, bend right knee, slide left foot out to the left and front , at the same time pull both palms down to the right and rear, look in direction of the palms;

2 **旋掌前擠** 身體左轉，重心左移，兩掌旋轉相搭，掌心相對，弓步前擠，目視兩掌方向（圖 11-2）；

b. Spin palms press forward – turn body left, shift weight left, palms whirl together, facing each other, bow stance press forwards, look in direction of the palms;

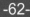

11 （十一）前趟
11.Wade Forward

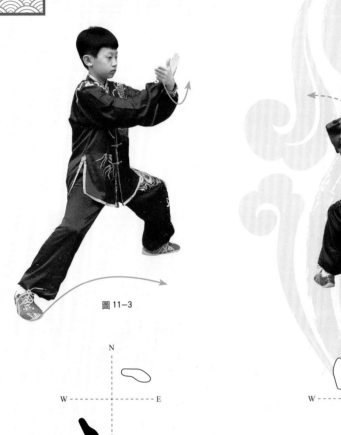

圖 11-3

圖 11-4

圖 11-4

圖 11-4

3 **翻掌擦腳**　身體微右轉再左轉，兩掌翻轉，掌背相對，右腳走內弧向右前方擦出，目視兩掌方向（圖 11-3；11-4）；

c. Flip hands slide foot – turn body slightly right then left, flip both palms, backs together, draw right foot in an inward arc and slide out to the front and right, look in direction of the palms;

（十一）前趨

11.Wade Forward

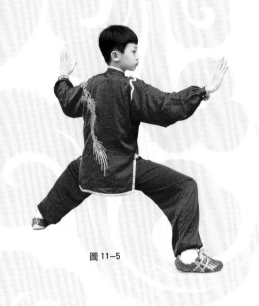

圖 11-5

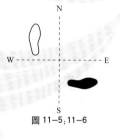

圖 11-5；11-6

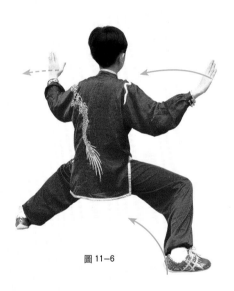

圖 11-6

4 **馬步分掌** 身體微左轉再右轉，重心右移，同時右掌內旋，兩臂分展，成右偏馬步，目視正前方（圖 11-5；11-6）。

d. Horse stance part palms – turn body slightly left then right, shift weight right, at the same time rotate right palm inwards, spread arms apart, adopt a right-biased horse stance, look straight ahead.

12 （十二）右掩手肱捶
12. Hide Hand and Strike with Fist (Right Side)

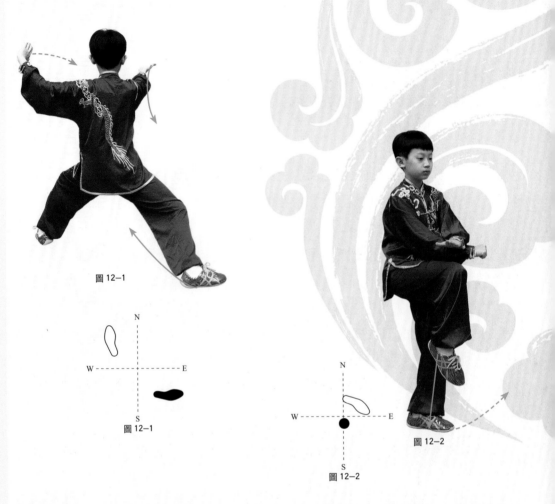

圖 12-1

圖 12-1

圖 12-2

圖 12-2

1 提膝合臂 身體左轉再右轉，提右膝，右掌變拳，兩臂相合，右拳在下，目視兩手方向（圖 12-1；12-2）；

a. Lift knee close arms – turn body left then right, raise right knee, right palm becomes fist, arms come together, right fist below, look in direction of the hands;

（十二）右掩手肱捶

12. Hide Hand and Strike with Fist (Right Side)

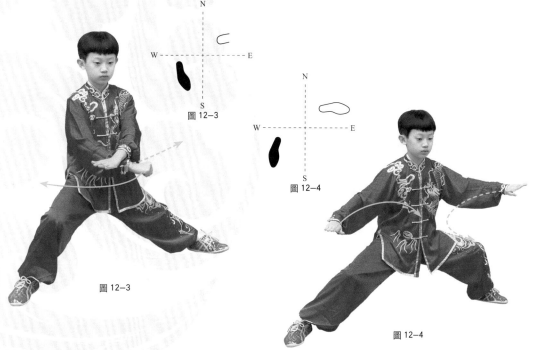

圖 12-3

圖 12-4

2 **震腳擦腳** 右腳下震于左腳內側，同時左腳向左前方擦出，目視兩手方向（圖 12-3）；

b. Thud foot pound fist – drop right foot with a thud to inside of left foot, at the same time slide left foot out to the left and front, look in direction of the hands;

3 **左移分掌** 身體左轉，重心左移，襠走下弧，兩臂螺旋分開，目視左掌方向（圖 12-4）；

c. Shift left part palms – turn body left, shift weight left, dip pelvis in a downward arc, both arms spiral apart, look in direction of left palm;

12 （十二）右掩手肱捶

12. Hide Hand and Strike with Fist (Right Side)

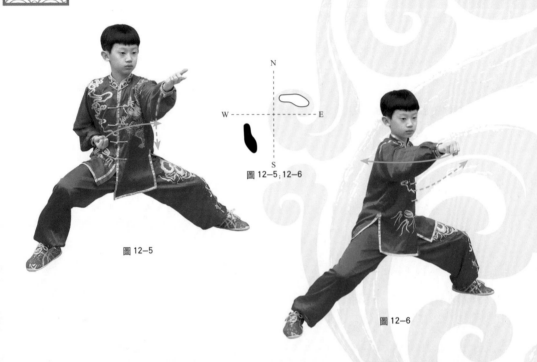

圖 12-5

圖 12-5；12-6

圖 12-6

4 **右移合臂** 身體右轉，重心右移，兩肘相合，左掌變槍手，右掌變拳，右拳掩于左肘后側，目視左手方向（圖 12-5）；

d. Shift right close arms – turn body right, shift weight right, both elbows come together, left palm forms a pistol, right palm becomes a fist, right fist is hidden behind left elbow, look in direction of left hand;

5 **弓步衝拳** 身體左轉，重心左移，右腳蹬地，以腰爲軸，右拳螺旋向前衝擊，同時左肘向后頂肘，目視右拳方向（圖 12-6）；

e. Bow stance punch fist – turn body left, shift weight left, thrust right foot, with waist as axis, right fist spirals forward in a punch strike, at the same time left elbow jabs backwards, look in direction of right fist;

（十二）右掩手肱捶

12. Hide Hand and Strike with Fist (Right Side)

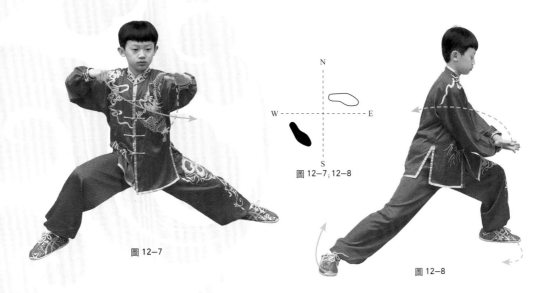

圖 12-7

圖 12-7；12-8

圖 12-8

6 撐掌頂肘 身體右轉，重心右移，右手曲肘向后頂肘發力，左掌向前撐掌，力達掌根，目視左掌方向。（圖 12-7）；

f. Brace palm jab elbow – turn body right, shift weight right, with right arm bent jab elbow backwards expressing force, brace left palm to front, expressing force through base of palm, look in direction of left palm;

7 左轉合臂 身體左轉，重心左移，兩臂劃弧相合，右臂在下，目視兩臂方向（圖 12-8）。

a. Left turn close arms – turn body left, shift weight left, arms arc and come together, right arm below, look in direction of the arms.

13 （十三）雙震腳
13.Thud with both feet

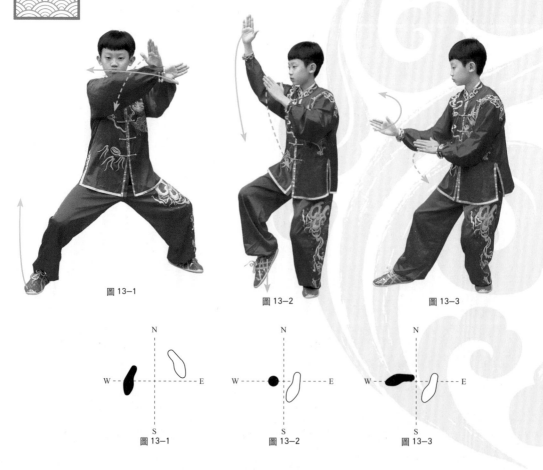

圖 13-1　　　　圖 13-2　　　　圖 13-3

圖 13-1　　　　圖 13-2　　　　圖 13-3

1 **右轉掄臂**　身體右轉，重心右移再左移，左腳尖內扣，右腳提起右移，腳尖點地成虛步，兩臂順時針劃弧落至腹前，右掌在前，兩掌心斜向下，目視右掌方向（圖 13-1；13-2；13-3）；

b. Right turn swing arms – turn body right, shift weight right then left, turn left toes inwards, lift right foot and shift right, rest on tips of toes and adopt empty stance, arms arc clockwise and drop to front of belly, right palm in front, palms tilted downwards, look in direction of the palms;

（十三）雙震腳

13.Thud with both feet

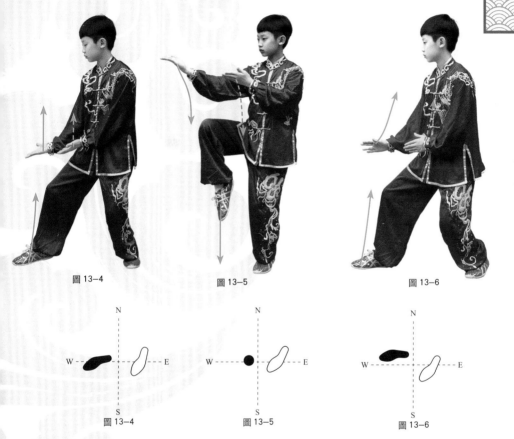

圖 13-4　　　　　　　圖 13-5　　　　　　　圖 13-6

圖 13-4　　　　　　　圖 13-5　　　　　　　圖 13-6

2 **上跳托掌**　兩掌外旋上托，同時兩腳上跳，右腳先起，目視兩掌方向（圖 13-4；13-5）；

c. Jump up lift palms – palms rotate outwards and lift up, at the same time jump up with both feet, right foot first, look in direction of the palms;

3 **震腳下按**　兩腳下震，左腳先落，重心在左腳，同時兩掌內旋下按，目視兩掌方向（圖 13-6）。

d. Thud foot press down – both feet land with a thud, left foot first, weight on left foot, at the same time rotate palms inwards and press down, look in direction of the palms.

14 （十四）蹬腳
14.Heel Kicket

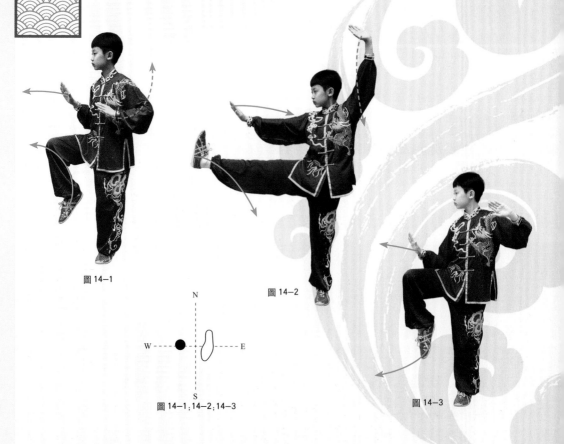

圖 14—1

圖 14—2

圖 14—3

圖 14—1；14—2；14—3

1 **提膝收掌** 兩掌向胸前回收，同時提右膝，目視前方（圖 14—1）；

a. Lift knee draw palms – draw palms to front of chest, at the same time lift right knee, look ahead;

2 **蹬腳架推** 右腳向前正蹬腿，力達腳跟，同時右掌向前推掌，力達掌根，左掌向頭頂上架，目視前方（圖 14—2；14—3）。

b. Kick out cover push – kick right leg straight out ahead, expressing force through the heel, at the same time push right palm ahead, expressing force through base of palm, left palm covers crown of head, look ahead.

（十五）玉女穿梭
15.Jade Maiden Working Shuttles

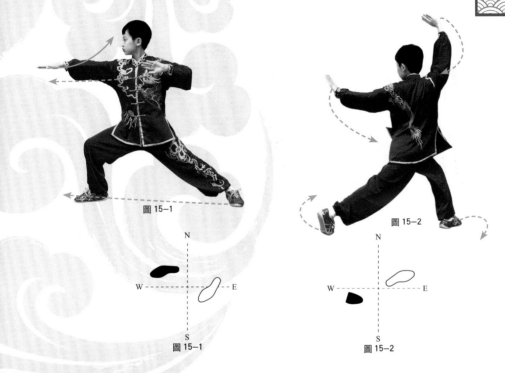

圖 15－1

圖 15－2

圖 15－1

圖 15－2

1 **上步穿掌** 右腳上步變弓步，同時右掌向前穿，掌心向下，左手下落向左后方撐掌，目視右掌方向（圖 15－1）；

a. Step forward jab palm – step right foot forward and adopt bow stance, at the same time jab right palm ahead, palm facing downwards, drop left hand and hold to left and rear, look in direction of right palm;

2 **騰空架推** 身體右轉，右腳蹬地，向前轉身跳兩步，右腳從左腳后側插出變叉步，同時左掌向前推出，力達掌根，右掌向頭頂上架，目視左掌方向。（圖 15－2）。

b. Flying jump cover push – turn body right, thrust right foot, at the same time jump two steps and turn around: pass right foot behind left foot to form cross stance, at the same time push left palm out to front, expressing force through base of palm, right palm covers crown of head, look in direction of left palm.

16

（十六）順鸞肘
16.Smooth elbow strike

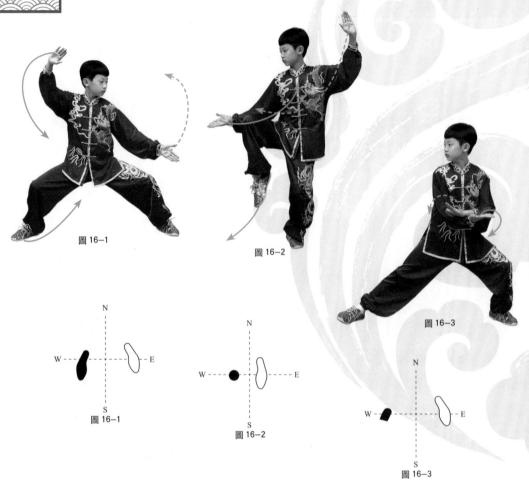

圖 16－1

圖 16－2

圖 16－3

圖 16－1

圖 16－2

圖 16－3

1 **擦腳合臂** 身體右轉，右腳以腳前掌碾轉，左腳尖內扣，提右腳向右擦出，同時兩臂劃弧相合，右臂在外，目視右方（圖 16－1；16－2；16－3）；

a. Slide foot close arms – turn body right, roll right foot around on ball of foot, turn left toes inwards, lift right foot and slide out to the right, at the same time arms arc and come together, right arm outside, look to the right;

（十六）順鸞肘
16.Smooth elbow strike

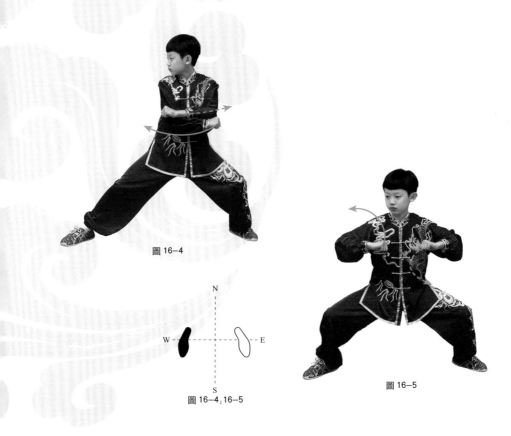

圖 16-4

圖 16-5

圖 16-4；16-5

2 馬步頂肘 身體微左轉再右轉，重心右移，兩掌變拳，兩臂曲肘，以肘尖爲力點向后發力頂肘，成右偏馬步，目視右方（圖 16-4；16-5）。

b. Horse stance jab elbows – turn body slightly left then right, shift weight right, palms become fists, elbows bent, jab elbows backwards forcefully with point of force in tip of elbows, adopt right-biased horse stance, look to the right.

17 （十七）金剛搗碓
17.Guardian Pounds Mortar

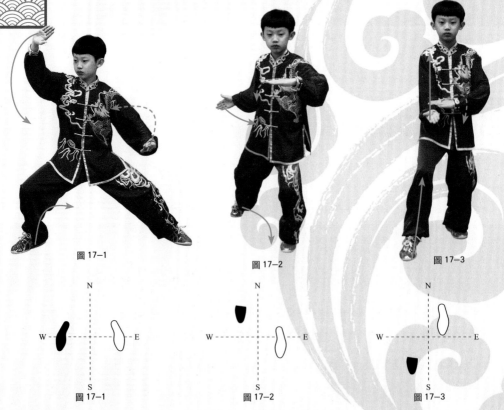

圖 17-1　　　　圖 17-2　　　　圖 17-3

圖 17-1　　　　圖 17-2　　　　圖 17-3

1 **變掌劃弧**　身體右轉，重心左移，同時兩拳變掌上下分開劃弧，目視右掌方向（圖 17-1）；

a. Open palms and arc – turn body right, shift weight left, at the same time arms arc apart up and down, look in direction of right palm;

2 **虛步撩掌**　右腳走內弧向前上步，腳尖點地成虛步，同時左手向前撩掌，右掌隨右腳向前和左掌相搭，左掌搭於右前臂，目視右掌方向（圖 17-2；17-3）；

b. Empty stance flick palm – step right foot forward bringing foot in an inward arc, rest on tips of toes and adopt empty stance, at the same time flick left palm forwards, right palm follows right foot forwards to meet left palm, place left palm on right forearm, look in direction of right palm;

（十七）金剛搗碓
17.Guardian Pounds Mortar

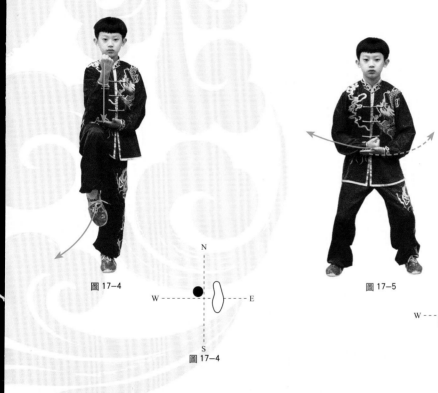

圖 17-4

圖 17-4

圖 17-5

圖 17-5

3 **舉拳提膝** 右掌變拳微下沉再上舉，與鼻同高，左掌收至腹前，掌心向上，同時提右膝，高過水平，腳尖下垂，目視前方（圖 17-4）；

c. Raise fist lift knee – right palm becomes fist, dip slightly before raising to nose level, draw left palm in front of belly, palm upwards, at the same time lift right knee, higher than level, toes hanging down, look ahead;

4 **震腳砸拳** 右腳下震，與肩同寬，重心偏左腳，兩腳平行，同時右拳以拳背砸于左掌上，目視前方（圖 17-5）。

e. Thud foot pound fist – drop right foot with a thud, shoulder width apart, weight slightly left, feet parallel, at the same time pound back of right fist onto left palm, look ahead.

18 （十八）收勢
18.Closing form

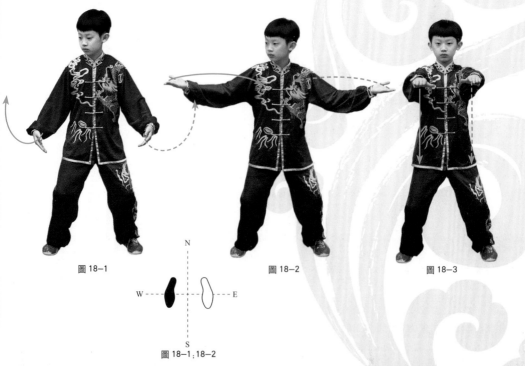

圖 18-1

圖 18-2

圖 18-3

圖 18-1; 18-2

1 變掌分開 右拳變掌，同時兩掌向兩邊分開，掌心向上，目視右掌方向（圖 18-1）；

a. Open palm and separate – right fist becomes palm, at the same time palms part to each side, palms facing upwards, look in direction of right palm;

2 翻掌相合 兩掌內旋翻掌，向前相合，與肩同寬同高，掌心向下，目視前方（圖 18-2；18-3）；

b. Flip palms bring together – rotate palms inwards and bring together in front, at shoulder height and shoulder width apart, palms facing downwards, look ahead;

（十八）收勢
18.Closing form

圖 18—4

圖 18—5

圖 18—4

圖 18—5

3 鬆肩下落 鬆肩墜肘，兩臂下落至兩腿外側，目視前方（圖 18—4）；

c. Relax shoulders drop down – relax shoulders and allow elbows to fall, drop arms to outside of legs, look ahead;

4 並步還原 左腳收至右腳內側，并步還原，目視前方（圖 18—5）。

d. Return to equal stance – bring left foot to inside of right foot, return to equal stance, look ahead.

【武術/表演/比賽/專業太極鞋】

正紅色【升級款】
XF001 正紅

打開淘寶天貓
掃碼進店

微信掃一掃
進入小程序購買

藍色【經典款】
XF8008-2 藍

黃色【經典款】
XF8008-2 黃色

紫色【經典款】
XF8008-2 紫色

正紅色【經典款】
XF8008-2 正紅

黑色【經典款】
XF8008-2 黑

綠色【經典款】
XF8008-2 綠

桔紅色【經典款】
XF8008-2 桔紅

粉色【經典款】
XF8008-2 粉

XF2008B（太極圖）白

XF2008B（太極圖）黑

XF2008-2 白

XF2008-3 黑

5634 白

XF2008-2 黑

【太極羊・專業武術鞋】

兒童款・超纖皮

XF808-1 銀

XF808-1 白

XF808-1 紅

XF808-1 金

XF808-1 藍

XF808-1 黑

XF808-1 粉

长袖款

短袖款

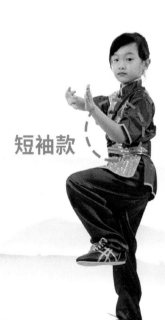

微信掃一掃

進入小程序購買

[學生鞋]
白波鞋(男女同款)

舒適防踢鞋頭:防踢防撞設計，細心呵護腳趾，讓小朋友享受運動的同時，健康快樂的成長。

貼心防護設計: 採用親膚材料製作，透氣不悶腳，輕盈舒適。

便捷魔術貼: 環保牢固，穿脫簡易，使用壽命長。

平穩防震後跟: 貼合足部，有效減輕足部壓力，緩解疲勞，柔軟減震。

矯正扁平足: 專業鞋墊，承托足弓，科學、有效的矯正扁平足。

微信掃描購買

天貓旗艦店

產品質檢報告

商標註冊證明書

商標註冊證

商業登記

[學生鞋]
黑皮鞋（男款）

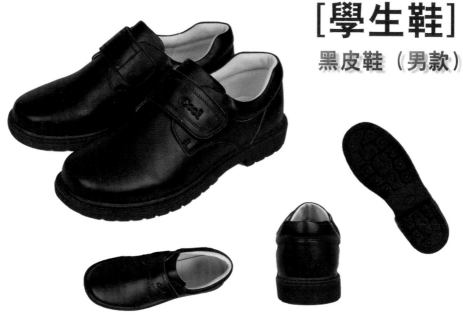

優質皮料製作： 易打理，厚度適中，光滑亮澤，透氣性好。
人性化鞋頭設計： 鞋頭寬鬆，不擠腳，讓腳趾自然發育。
防臭仿豬皮內裏： 仿豬皮加海波麗搭配，腳趾舒適，富有彈性。
不磨腳後包： 柔軟舒適，貼腳不掉腳。
耐磨防滑鞋底： 經典凹凸底紋設計，防水防滑，耐磨有彈性，防止摔跤。

微信掃描購買　　　　　天貓旗艦店

黑皮鞋（女款）

【專業太極服】

多種款式選擇・男女同款

微信掃一掃

進入小程序購買

黑白漸變仿綢

淺棕色牛奶絲

白色星光麻

亞麻淺粉中袖

白色星光麻

真絲綢藍白漸變

【武術服、太極服】

多種顏色選擇・男女同款

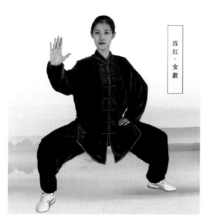
玫紅・女款

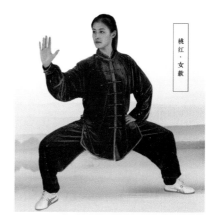
桃紅・女款

【太極扇】

武術/廣場舞/表演扇

可訂制LOGO

紅色牡丹

粉色牡丹

黃色牡丹

紫色牡丹

黑色牡丹

藍色牡丹

綠色牡丹

黑色龍鳳

紅色武字

黑色武字

紅色龍鳳

金色龍鳳

純紅色

紅色冷字

紅色功夫扇

紅色太極

打開淘寶天猫APP

掃碼進店

微信掃一掃

進入小程序購買

香港國際武術總會裁判員、教練員培訓班
常年舉辦培訓

　　香港國際武術總會培訓中心是經過香港政府注册、香港國際武術總會認證的培訓部門。爲傳承中華傳統文化、促進武術運動的開展，加强裁判員、教練員隊伍建設，提高武術裁判員、教練員綜合水平，以進一步規範科學訓練爲目的，選拔、培養更多的作風硬、業務精、技術好的裁判員、教練員團隊。特開展常年培訓，報名人數每達到一定數量，即舉辦培訓班。

報名條件：熱愛武術運動，思想作風正派，敬業精神强，有較高的職業道德，男女不限。

培訓內容：1.規則培訓；2.裁判法；3.技術培訓。考核內容：1.理論、規則考試；2.技術考核；3.實際操作和實踐（安排實際比賽實習）。經考核合格者頒發結業證書。培訓考核優秀者，將會錄入香港國際武術總會人才庫，有機會代表參加重大武術比賽，并提供宣傳、推廣平臺。

聯系方式

深圳：13143449091（微信同號）
　　　13352912626（微信同號）
香港：0085298500233（微信同號）

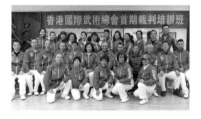

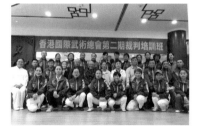

國際武術教練證　　國際武術裁判證

微信掃一掃

進入小程序

香港國際武術總會第三期裁判、教練培訓班

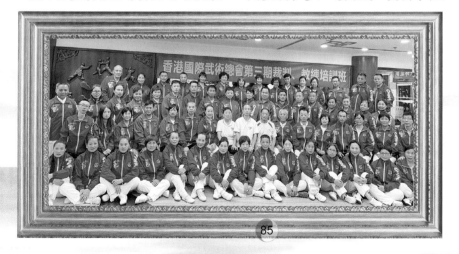

打開淘寶APP

掃碼進店

【出版各種書籍】

申請書號>設計排版>印刷出品
>市場推廣
港澳台各大書店銷售

冷先鋒

【正版教學光盤】

正版教學光盤 太極名師 冷先鋒 DVD包郵

 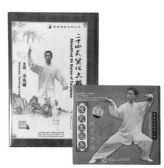

 打開淘寶天貓APP

掃碼進店

 微信掃一掃

進入小程序購買

國際武術大講堂系列教學之一
《校園武術規定教材 – 太極拳》

香港先鋒國際集團　審定

太極羊集團　　贊助

香港國際武術總會有限公司　出版

香港聯合書刊物流有限公司　發行

代理商：台灣白象文化事業有限公司

書號：ISBN 978-988-74212-5-2

香港地址：香港九龍彌敦道 525 -543 號寶寧大廈 C 座 412 室

電話：00852-95889723 \91267932

深圳地址：深圳市羅湖區紅嶺中路 2018 號建設集團大廈 B 座 20A

電話：0755-25950376\13352912626

台灣地址：401 台中市東區和平街 228 巷 44 號

電話：04-22208589

印刷：香港嘉越发展有限公司

印次：2020 年 7 月第一次印刷

印數：5000 冊

總編輯：冷先鋒

責任編輯：冷飛鴻

責任印制：冷修寧

版面設計：明栩成

圖片攝影：陳璐

網站：https://taijixf.com　　　www. taijiyanghk.com

Email: lengxianfeng@yahoo.com.hk